LOVE
IS THE
WINE

TALKS
OF A SUFI MASTER
IN AMERICA

LOVE
IS THE
WINE

TALKS
OF A SUFI MASTER
IN AMERICA

SHEIKH MUZAFFER OZAK
AL JERRAHI AL HALVETI

EDITED AND COMPILED BY
SHEIKH RAGIP FRAGER

LOVE IS THE WINE

Copyright © 1987 By Robert Frager
ISBN: 0-89314-425-8
Second Edition 1999
Library of Congress Catalog Card Number 98-83050

Printed in the U.S.A.

Photograph Back Cover Douglas Aronson

Title Page Calligraphy by Mohammed Bouthelidja-
God is the Generous One.

Front Cover Illustration *Dancing Dervishes* from
The Metropolitan Museum of Art, Purchase, Rogers Fund
and the Kervorkian Foundation Gift, 1955. (55.121.10.18)
Photograph © 1980 Metropolitan Museum of Art.

PUBLISHED BY
THE PHILOSOPHICAL RESEARCH SOCIETY
3910 Los Feliz Boulevard Los Angeles California 90027 USA
☎ (323) 663 2167 Fax (323) 663 9443
Website www.prs.org Email info@prs.org

TABLE OF CONTENTS

INTRODUCTION TO THE
SECOND EDITION

The first edition of *Love is the Wine* has served as an introduction to Sufism and has touched the hearts and minds of many sincere seekers. A surprising number of people have been inspired to practice Sufism by this collection of the talks of Sheikh Muzaffer Ozak. I am deeply grateful to have been instrumental in helping to bring my sheikh's profound wisdom and deep love of God to many who were not privileged to have met him in person.

A Short Introduction To Sufism

Sufism is the mystical core of Islam. It began in the ninth century A.D., approximately two hundred years after the birth of Islam, when the adoption of the moral and ethical teachings of Islam created a climate in which Sufism could develop and flourish. Sufism is found primarily in the Middle East and in Islamic countries, but its ideas, practices, and teachers can be encountered throughout the world.

In its universal sense, Sufism includes the mystical aspects of all religions, and all mysticism has the same goal, the direct experience of the Divine. Religion is a tree whose roots are exoteric religious, moral and ethical practices. The branches of that tree are mysticism. The fruit of the tree is Truth.

One who practices Sufism is called a Sufi, a dervish, or a faqir. *Sufi* has several meanings in Arabic, including "pure" and "wool." (Early Sufis wore simple wool cloaks, and they sought inner purity).

Dervish is a Persian term derived from *dar,* or door. It refers to one who goes from door to door (begging) or one who is at the threshold (between awareness of this world and awareness of the divine).

Faqir is Arabic for a "poor person." In Sufism, this does not refer to those poor in worldly goods, but to those who are "spiritually poor," who recognize their need for God's mercy, and whose heart are empty of attachment to anything other than God.

A Sufi teacher, known as a sheikh, is a leader and spiritual guide to a community of dervishes. Dervishes must receive formal, written authorization from their own sheikh before they can teach or use the title of sheikh.

THE CREATION OF THIS BOOK

It took me two years to edit and compile this material for the first edition. At first, I was reluctant to edit the transcripts of Sheikh Muzaffer's talks. How could I change even a single word of my own sheikh's teachings? I was a relative newcomer to Sufism, and Sheikh Muzaffer's depth of wisdom and understanding were based on his immersion in the Sufi tradition since childhood. His father was a Sufi and he grew up with a succession of teachers and tutors in varied aspects of Sufism and related fields of study.

I soon realized that I had to edit more actively. Sheikh Muzaffer's talks were marvelous examples of oral teachings, but this rarely made for good English prose. I struggled to do my best to retain Sheikh Muzaffer's wisdom, warmth, and humor as I turned his talks into written form. In addition to polishing the prose, I also organized the material into topic areas. And, as Sheikh Muzaffer would frequently repeat major topics or retell key stories, I often pieced together different

variations into a single whole.

In my own relative ignorance, I may well have distorted or omitted essential elements in Sheikh Muzaffer's teachings. The wisdom and inspiration in this book are definitely his, and I am sure that any errors are mine.

The material in this book is taken from talks and lectures that span a period of over five years, beginning with Sheikh Muzaffer's visits to California in 1980 and 1981, and his subsequent Spring and Fall trips to the East Coast until his passing in 1985. In some cases, Sheikh Muzaffer addressed large audiences of people who were interested in Sufism but who knew little or nothing about it. At other times, he taught small groups of his American dervishes, who brought to him questions based on their own sincere practice of Sufism and their struggles along this Path of Truth.

Most of the stories of Satan in the section on temptation, for example, were taken from an after-dinner talk given at the home of two American dervishes. This couple loved Efendi deeply, but they also had a tremendous amount of inner work to do. If my sheikh came to my house and talked about Satan all night, I hope I would have gotten the hint and tried to understand what he was telling me! (A sheikh will generally try indirectly to illuminate a dervish's faults or limitations.)

Like many other Sufi teachers, Sheikh Muzaffer would rarely teach in a linear fashion. He would typically approach a topic from a variety of viewpoints, and liberally insert stories and parables to illustrate his points. Often one story would lead to another, or a reference within one story would call up another story that became "nested" within the first one. There can be a powerful synergy when these elements come together in a rich, three-dimensional whole.

For over ten years, in my own teaching of Sufism I have found that I have retold over and over again the stories in this book. Sheikh Muzaffer once said to Sheikh Tosun, the senior Jerrahi sheikh in the United States, "Keep repeating these stories. You may need to retell them a thousand times for people to understand them." I have also found that as my own practice and understanding of Sufism have matured, I have come to appreciate new levels of meaning in these profound teaching tales. I urge you to read and re-read this book. For me, it is a treasury filled with priceless items of Sufi wisdom.

A Lesson from my Master

Sheikh Muzaffer was my spiritual mother and father. He gave birth to my life as a dervish, a life of seeking God while serving others and fulfilling my duties in the world.

I came to this path after years of spiritual searching and mystical practice. I followed a deeply committed meditation practice in the yoga tradition for more than ten years. For many years, I also enjoyed the spiritual companionship and guidance of both Jiyu Kennett Roshi and Swami Radha, who were deeply knowledgeable spiritual masters in the Zen Buddhist and yoga traditions respectively.

Still earlier when I was in my twenties, I lived in Japan and was blessed with the opportunity to study personally with two great Japanese teachers. My first spiritual teacher was Morihei Ueshiba, a great mystic and the founder of the martial art of Aikido. My second teacher was Master Tempu Nakamura, who had been the spiritual tutor to the Japanese Imperial family and to many of the most influential officials, scientists, and business people in Japan.

In addition to these spiritual disciplines, I had also undergone several kinds of psychotherapy, had participated in various

encounter/growth groups, and taken part in numerous psychological or psychotherapeutic seminars and workshops.

In spite of all my previous study and training, I often felt like a baby at the feet of Sheikh Muzaffer. One of my most powerful spiritual experiencs occurred on my first trip to New York to see him, six months after my becoming a dervish. He singled me out at one point and directed me to ask him a question. (A sheikh generally learns a great deal from the questions or comments of the dervishes.) I asked him about a particular Sufi meditation practice, and Sheikh Muzaffer replied, "Will you leave your religion when I die?"

Although the answer seemed totally unrelated to my question, it was suddenly clear to me that Sheikh Muzaffer was addressing what was hidden several levels below my question. He saw how much of my enthusiasm for the Sufi path was actually my love for him, although I had thought that I was sincerely following Sufism as a spiritual discipline, as a way to find God. Now I suddenly realized that I was very much attached to Sheikh Muzaffer and was trying to please him, even more than I was seeking God. This was a crushing revelation as I was exposed (yet once again!) to my own limitations and lack of sincerity. As these unconscious parts of myself were revealed to me, I simultaneously felt Sheikh Muzaffer's kindness and love for me. His caring and compassion were not lessened in the slightest by his knowledge of my inner failings. I could feel him holding *all* of me in his loving heart—my strengths and weaknesses, my ideals and limitations.

This whole experience felt like a kind of miraculous psychic surgery. Sheikh Muzaffer uncovered hidden and unpleasant aspects of myself, and because he did this with love and complete acceptance, I could begin to accept these parts of

myself, instead of immediately repressing or rationalizing away these insights.

This experience is a model of what sheikhs can do for the dervishes. Real sheikhs can turn their dervishes inside out, initiate the process of inner cleansing and healing, and then help put us back together again. This process requires both love and wisdom. There is a miraculous healing that only occurs when we are seen and understood and still loved and accepted, faults and all.

I am delighted that this new edition of *Love is the Wine* is being published by the Philosophical Research Society. The founder of the Philosophical Research Society, Manly P. Hall, wrote brilliantly about the wisdom and power of all the world's great spiritual traditions. He wrote relatively little about Sufism, because there was very little available to him; most of the Sufi translations in his day were poor or even misleading. It is in the spirit of Manly P. Hall that I offer this new edition of *Love is the Wine,* as one ray in the magnificent rainbow of the world's treasury of spiritual wisdom.

This book is meant to convey a taste of living Sufism. It contains the actual teachings of a great Sufi master who brought a great mystical tradition to the West. Sheikh Muzaffer was a visitor to the West who knew only a handful of English words, yet he understood deeply the hearts of his Western students. For years, he served his Western dervishes with all his power, compassion, and wisdom. He taught unstintingly from morning to night whenever he was here, and he generously spent untold hours with a constant stream of Western visitors who went to see him in Turkey. Sheikh Muzaffer was deeply touched by the longing for God that he found in so many Western hearts. The teaching in this book is a sample of his generous response to that longing.

INTRODUCTION

I met Sheikh Muzaffer (God's Mercy upon him) in April 1980. The psychology graduate institute I founded had invited him and his dervishes to be guests of the school while he was in Northern California. Two of my faculty members had made all the arrangements, and so I had no contact with the dervishes until they arrived.

I was sitting in my office, talking on the telephone, when an imposing, heavyset man walked by. He glanced at me and walked on, not even breaking his stride. The moment he glanced at me, time seemed to stand still. It felt as if he instantly knew all about me, as if all the data of my life was read and analyzed as if in a high-speed computer in a fraction of a second.

I had the sense that he knew everything that led into my being in my office, even to making that telephone call, and that he also knew how it would all come out.

A voice inside me said, "I certainly hope that is the sheikh. Because if that was just one of his dervishes, I don't think I can handle meeting his sheikh!"

After a while I went out to greet the sheikh and his dervishes and to welcome them on behalf of the school. As I expected, the man I first saw was Sheikh Muzaffer Efendi. In his presence I felt a blend of great power and wisdom on the one hand, and deep love and compassion on the other. The power that radiated from him would have been almost unbearable if it wasn't for the equally strong love that he radiated as well.

He had the powerful frame of a Turkish wrestler. His hands were huge, the largest I've ever seen. His voice was a deep, rolling bass, the richest and deepest voice I've heard outside an opera house. His face was extremely mobile. One moment he would appear stern and grave, the next he became the quintes-

sential comic storyteller. His eyes were clear and piercing—sometimes fierce like a hawk's, and sometimes loving and twinkling with humor.

That evening Efendi invited me to sit with him at dinner. After dinner, he told two Sufi teaching stories. Hearing him speak, I realized that the books I'd read on Sufism had not begun to convey the power of this teaching technique. Reading collections of unrelated stories, taken out of context, was nothing like hearing a Sufi teacher in person. The first story seemed to open me up, and the second knocked the moral home.

When Efendi was done, I suddenly noticed that the room was filled with people, dervishes and my own students. While he was telling the stories, he seemed to be telling them to me alone, and I had no sense there was anyone else in the room.

The first story is as follows:

Once, a man loaned some money to an old friend. Some months later, he needed the money and went to his friend's house, in a neighboring town, to ask for repayment of the loan. His friend's wife told him that her husband was visiting someone across town. She gave him directions and he started off.

On the way he passed a funeral procession. Not being in any hurry, he decided to join the procession and offer a prayer for the soul of the dead.

The town cemetery was very old. In digging the new grave, some older graves were exhumed. As the man was standing by the new grave, he noticed a freshly dug up skull by his side. In between the two front teeth of the skull, there was a single lentil. Without thinking, the man took the lentil and popped it into his mouth.

Just then an ageless-looking man with a white beard came up to him and asked, "Do you know why you are here today?"

"Why yes, I'm visiting this town to meet my friend."

"No, you were here to eat that lentil. You see, that lentil was meant for you. It was not meant for the man who died some time ago, so he could not swallow it. It was meant for you and had to come to you."

Efendi commented, "That is true for everything. God provides your sustenance. Whatever is meant to come to you, you will receive."

Then he told the second story.

There was a wealthy man in Istanbul who decided one year to corner the market in rice. When the farmers finished their harvesting, he sent his servants to the gates of the city. There, they bought the farmers' rice and brought it to warehouses their master had rented. None of the rice harvest made it to the marketplace. The wealthy man figured he could make a fortune with his rice monopoly.

Once all the rice was stored, his foreman took him through the warehouses. Rice was stored by type and quality. In one corner of the last warehouse, the finest rice was stored. This was the best variety of rice, which had been planted in the finest soil, and had received the optimum amount of sun and water. When the man saw this rice, whose grains were twice as large as the average rice grains, he decided to take some of it home and have it for dinner that night.

At dinner, he was presented with a plate of this rich, wonderful rice, cooked with butter and spices. He took a big spoonful, but the rice got stuck in his throat. He couldn't swallow it or spit it out.

No matter what he did, the rice remained stuck. Finally he called the family doctor. The doctor poked and prodded but he too was unable to dislodge the rice. Finally the doctor said, "I'm afraid you'll need a tracheotomy. It's a simple operation. We'll cut into your throat and remove the rice directly."

The man was appalled at the idea of having his throat cut and so he consulted an eye, ear, nose and throat specialist. Unfortunately the specialist recommended the same operation.

Then the man remembered the Sufi sheikh who had been his family's spiritual advisor for years and who was reputed to have healing powers. He went to see the sheikh, who told him, "Yes, I know how you can cure your condition, but you will have to do exactly what I tell you. Get on a plane tomorrow and go to San

Francisco. Then take a taxi to the St. Francis Hotel. Go to room 301, turn to your left, and your condition will be taken care of."

Because of the sheikh's reputation and also because he would rather do anything than have his throat cut, the man took a plane to San Francisco.

He was terribly uncomfortable with the rice stuck in his throat. Breathing was difficult and he could barely get down a little water from time to time.

Once he arrived in San Francisco the man went to the St. Francis Hotel and went up to room 301. So far so good. At least the hotel and the room the sheikh specified were there.

He knocked on the door and, unlatched, it opened part way. He slowly pushed the door open and peered in. On his left a man lay sleeping in bed, gently snoring. Suddenly the wealthy man sneezed. With that sneeze, the rice was expelled from his mouth into the mouth of the sleeping man, who automatically swallowed it as he woke up.

In Turkish, the awakened man exclaimed, "What's going on? Who are you?" Amazed to find a fellow countryman in San Francisco, the wealthy man told him the whole story. Both were astonished by what happened. The man turned out to be a native of Istanbul, who even lived in the same neighborhood as the wealthy man.

When he returned home, the wealthy man immediately went to the sheikh. The sheikh explained that the rice he tried to eat was not meant for him. It was meant for the man who had swallowed it. Since that rice was not meant for the wealthy man, he could not swallow it. The only solution was to get that rice to the man for whom it was destined.

The sheikh said, with great emphasis, "Remember, whatever is meant for you is bound to come to you. And whatever is meant for others is bound to come to them also."

The man went home and thought long and hard about his experience and about what the sheikh had said. The next morning he opened his warehouses and distributed all the rice to the poor of Istanbul.

Efendi added, "That is true. Whatever is meant for you, and that includes both material and spiritual benefits, is bound to come to you. It may have to come all the way from Istanbul to San Francisco, or even by a more roundabout route, but it *will* come to you."

I went home that evening and thought about the stories and about what Sheikh Muzaffer had said. I reflected on how hard I pushed myself and how often I worried about failing. I realized that I would probably work just about as hard, and a lot more happily and efficiently, if I were confident that whatever I was meant to receive would surely come to me.

The next day, when I saw Efendi, I told him how powerfully the stories he had told the night before had affected me. I said that if I only remembered those stories my life would be very different. He looked at me deeply and intently, and said "You will never forget them!"

What he said was true. Although I remember many of the stories I have heard him tell, these two remain the clearest. Each detail seems etched in my mind.

What I said was true also. Since that time, I have felt a different sense of trust and serenity than ever before. I have at least tasted the truth that God provides for all of us far better and far more bountifully than we generally imagine.

Almost half of this collection of talks and stories is taken from Efendi's two visits to California. On those visits, the major part of his audience consisted of students of psychology who were interested in spirituality. In some areas, such as the chapter on dreams, Efendi goes into far more detail than I have heard or read elsewhere.

The other half of this collection comes from talks that I and others recorded during Efendi's frequent visits to New York. I had the good fortune to listen to Efendi twice a year, spring and fall, from 1981 until his passing in 1985. His audience for these talks mainly consisted of American dervishes who were learning about both Sufism and Islam.

The teachings and stories collected in this book are unique.

They are presentations of Sufi thought to an American audience by a full-fledged Sufi master. This is neither a scholarly treatise on Sufism nor a collection of stories and writings encapsulated within an ancient Middle Eastern religious and cultural tradition that few Western readers even begin to understand. These teachings are from the living tradition of Sufism adapted and oriented to modern Westerners.

Sheikh Muzaffer Ozak was the head of the Halveti-Jerrahi Order, a three-hundred-year-old branch of one of the great Sufi orders. He was acknowledged in Turkey as one of the few great living sheikhs, or Sufi teachers. Efendi was uniquely suited to bring the richness of the full Sufi tradition to the West. He understood Westerners as almost no Sufi master before him has. His religious bookshop in Istanbul attracted hundreds of Western seekers visiting Turkey. Efendi made over twenty trips to Europe and the United States, often staying one to two months at a time. In his travels, he initiated hundreds of Americans and Europeans into the Halveti-Jerrahi Order, interpreted their dreams, and answered their questions about everything from theology and mysticism to marriage and earning a living.

These teachings have profoundly affected my own life, from the time I first met Efendi. I have edited and compiled his talks because it was his wish to have his teachings spread to as wide an audience as possible. I hope it will touch your life as it did mine.

I am deeply grateful to Sheikh Tosun Bayrak, who was appointed by Efendi as my guide in this path of truth. He has encouraged and inspired me to edit and compile this book, and it is mainly his own sensitive and sophisticated translations of Efendi's talks that made this all possible.

Sheikh Tosun and I were blessed with the good fortune of editing the final draft of this manuscript in the holy city of Medina, the home and final resting place of the Prophet Muhammed (God's Peace and Blessings upon him). The Prophet's life has provided countless examples of priceless guidance and a model of the heights of human achievement for all dervishes from the very start of Sufism until today. The city of

Medina is permeated with the Prophet's presence. I pray that his light shines through these writings and touches the hearts of all who read this book.

In the Turkish and Arabic linguistic traditions, the names of saints, prophets and other holy beings are always followed by an honorific phrase. It is considered impolite and disrespectful to say "Jesus" or "Moses" as if you were speaking of your neighbor next door. However, since these formal phrases seem alien and cumbersome to Western readers, I have given the honorific phrase for only the first mention of each name within a given chapter or story. In the text you will find "Muhammed (God's Peace and Blessings upon him)".

Other great Messengers of God include Abraham, Moses and Jesus, whose names are followed by "God's Peace be upon them."

The names of family members and Companions of the Prophet Muhammed are followed by "May God be pleased with him [or her]."

The names of great Sufi saints are followed by "May his [or her] soul be sanctified."

The names of departed Sufi teachers are followed by "God's Mercy upon him [or her]."

The editor wishes to express his deep gratitude to Nuriya Janss, whose transcriptions of Efendi's talks and transformation of scattered notes into a single manuscript made this book possible. I am also very grateful to Nuran Reis, who was an invaluable help in manuscript preparation, and to Moussa Keller and the many other dervishes and students who read and commented on the manuscript. Finally, I wish to express my gratitude to my publisher, Kabir Helminski, whose support has been invaluable from the beginning.

Any errors or inaccuracies in this book are due to the ignorance and heedlessness of the editor.

Sheikh Ragip Frager,
of the Halveti-Jerrahi Order

Medina
Rajab 18, 1407 A.H.
(March 18, 1987)

SUFISM

SUFISM is not different from the mysticism of all religions. Mysticism comes from Adam (God's Peace upon him). It has assumed different shapes and forms over many centuries, for example, the mysticism of Jesus (God's Peace upon him), of monks, of hermits, and of Muhammed (God's Peace and Blessings upon him). A river passes through many countries and each claims it for its own. But there is only one river.

Truth does not change. People change. People try to possess truth and keep it for themselves, keep it from others. But you cannot own the truth.

The path of Sufism is the elimination of any intermediaries between the individual and God. The goal is to act as an extension of God, not to be a barrier.

To be a dervish is to serve and to help others, not just to sit and pray. To be a real dervish is to lift up those who have fallen, to wipe the tears of the suffering, to caress the friendless and the orphaned.

Different people have different capacities. Some can help with their hands, others with their tongue, others with their prayers, and others with their wealth.

You can get there by yourself, but that is the hard way. Our personal goals all lead to the same end. There is only one truth. But why deny the thousands of years of experience found in religion? There is real wisdom available from so many years of seeking and trial and error.

A great mistake is to have only half a religion. That keeps you from real faith. It is a terrible mistake. Seeing someone who is

only half a doctor is terribly dangerous. Someone who is half a ruler is a tyrant.

Many struggle in the maze of religion and religious differences. They are like dogs fighting over a bone, seeking their own selfish interests. The solution is to remember that there is only one Creator, who provides for all of us. The more we remember the One, the less the fighting.

A Sufi sheikh is like a doctor, and a student is someone who is sick at heart. The student comes to the sheikh for healing. A real sheikh will give a certain diet and certain medications to cure the person's ills. If students follow their sheikh's prescriptions, they will be cured. If not, they may be destroyed. Patients who misuse their doctors' prescriptions are courting disaster.

At a higher level the relation of a sheikh and students is like a bunch of grapes and the branch. The sheikh ties the grapes to the tree, to the sap and the source of the sap.

It is extremely important to understand this connection. It is like that between the bulb and the electricity. The power is the same. Some sheikhs have 20 volts and others 100 volts, but it is all the same electricity.

The eyes are the windows of the soul. By looking at students the sheikh connects them. There can be great power in the gaze of a sheikh.

The first stage is to have faith. The first step of that stage is faith in one's sheikh. The expression of that is to submit to the sheikh. Through that submission, your arrogance will be transformed to humbleness, your anger and negativity will be transformed to good-naturedness and softness. This first step is a very big one.

Not everyone who wears a turban, fancy robes, or other special clothing is a sheikh. But once you find a sheikh, through God's Will, the first step is submission.

The questioning and doubting which is so much emphasized in the West today may also bring you to truth. In fact, there is something blind in unthinking submission. It may be best to look, search, and think first, to choose to follow a sheikh only when you have resolved all your doubts and questions.

In our tradition it is generally considered a great breach of etiquette to question or to doubt your sheikh. However, it may be all right to question if by having your questions answered your faith becomes clearer and firmer.

Even the prophet Abraham asked God, "How can you bring the dead back to life?" God replied, "Abraham, don't you have faith in me? Do you doubt me?" Abraham answered, "Yes, I have faith, and You know what is in my heart. But I just wanted to see with my own eyes."

There are four ways to faith. The first is the way of knowledge. Someone comes to you and tells you about something you have never seen. For example, many people talked about this land, but I had never seen it. Eventually, I got on a plane and saw your country from the airplane window with my own eyes. When I saw your country for myself my faith was stronger. Now that I am here my faith is stronger still. The final level would be to *become* a part of this land.

The four ways to faith are:

knowledge of something
sight of something
being in something
becoming something

It is good to have doubt, but you should not *stay* in doubt. Doubt should lead you to truth. Do not stay in the questions. The mind can also fool you. Knowledge and science can fool you. There is also a state which is a part of some people's destiny— that the eyes which see will stop seeing, and the ears which hear will stop hearing, and the mind which figures out things will cease to figure things out.

In the case of the prophet Abraham, his people were idol worshipers. He sought to find God. He looked at the brightest star and said, "You are my Lord." Then the full moon came out. It was far bigger and brighter than any of the stars. Abraham looked at the moon and said, "You are my Lord." Then the sun came up and the moon and stars disappeared. Abraham said, "You are the greatest, You are my Lord." Then night came and the sun disap-

peared. Abraham said, "My Lord is the One who changes things and who brings them back. My Lord is the One who is behind all changes."

You see, through this step by step process, the prophet Abraham came from idol worship to the true worship of God. He saved his people from falsity. You can indeed reach unity through multiplicity.

There is a battle between the *nafs,* the lower self, and the soul. This battle will continue through life. The question is, who will educate whom? Who will become the master of whom? If the soul becomes the master, then you will be a believer, one who embraces Truth. If the lower self becomes master of the soul, you will be one who denies Truth.

* * *

It is said that a sheikh should never be the guest of a sultan, and that even if a sheikh does visit a sultan the sultan is *his* guest. That is, the sheikh goes to teach and to benefit the sultan, not to receive anything from him. Even a sheikh has to guard against the temptations of money, fame and power.

Some years ago, the Sultan of the Ottoman Empire began coming to the meetings of our Order. The Sultan was very much impressed by the wisdom of the Jerrahi sheikh, and he also loved the zikr ceremony of the dervishes.

After a couple of months the Sultan said to the sheikh, "I have been truly impressed and inspired by my visits here, and by you and your dervishes. I wish to support you in whatever ways I can. Please, ask me for anything."

This was quite an offer, carte blanche from the ruler of one of the greatest empires on earth.

The sheikh said, "Yes, my Sultan, you can do one thing for me. Please do not come back to us."

The shocked Sultan asked, "Did I do anything wrong? I don't know all the Sufi rules of etiquette, and I'm sorry if I have offended you."

"No, no," said the sheikh. "You have not offended me at all. The problem is not with you, but with my dervishes. Before you came, they would pray and chant the Divine Names for God's sake alone. Now when they do their prayers and chanting, they think of you. They think of earning your approval and about the wealth and power that might be gained by those who win your favor. No, my Sultan, it is not you but us. I'm afraid we are not spiritually mature enough to handle your presence here. That is why I am forced to ask you not to come back."

* * *

Once, the Sultan was riding through the streets of Istanbul, surrounded by courtiers and soldiers. The whole population of the city turned out to see the Sultan. Everybody bowed as the Sultan passed, except for a single ragged dervish.

The Sultan halted his procession and had the dervish brought to him. He demanded to know why the dervish did not bow when he passed.

The dervish replied, "Let all these people bow to you. They all want what you have—money, power, status. Thank God these things mean nothing to me any longer. Furthermore, why should I bow to you when I have two slaves who are your masters?"

The crowd gasped and the Sultan turned white with rage. "What do you mean?" he cried.

"My two slaves who are your masters are anger and greed," the dervish said calmly, looking the Sultan full in the face.

Recognizing the truth of what he heard, the Sultan bowed to the dervish.

* * *

God has said, "I, who cannot be contained in all the universes upon universes, fit into the heart of the believer." Now God does not actually fit into human hearts. God cannot be limited to a place. God's expressions fit into *all* people's hearts. We are not "part" of God, because God is indivisible. Humanity is God's

creation. God's expression in our hearts is that we are God's regents, God's representatives. We are the expression, the visible example of God. And so, God's Mercy is expressed through the thoughts and actions of one person, God's Compassion through another, God's Generosity through another.

There is the essence of God and there are the attributes of God. The essence is impossible for us to understand. We can begin to understand the attributes. In fact, part of a Sufi education is to understand those attributes in yourself.

God has said, "My servants will find Me as they see Me." This does not mean if you think of God as a tree or as a mountain that God will be that tree or mountain. If you think of God as merciful, or loving, or as angry or vengeful, that is how you will find God.

It is permissible in Sufism to talk about all of God's attributes. Finally, the Sufi reaches the stage of submission, and then ceases to ask questions.

There is electricity everywhere, but if you have only three light bulbs, all you will see is those three bulbs. You have to be conscious of yourself. That is the beginning and the extent of it. Only by knowledge of yourself will you understand certain attributes. The connection to the attributes is through self-understanding. Outwardly you will find nothing.

All of creation is God's manifestation. But, as some parts of the earth receive more light than others, some people receive more light. The prophets received the most Divine light. Besides quantity there is quality. There is the question of what attributes are being manifested. Some people are manifestations of different Divine attributes. The prophets manifest all of the Divine attributes. The moon reflects the light of the sun. The sun is Truth; the moon is each prophet.

LOVE

THE essence of God is love and the Sufi path is a path of
love. It is very difficult to describe love in words. It is like
trying to describe honey to someone who has never tasted
or even seen honey, who doesn't know what honey is.

Love is to see what is good and beautiful in everything. It is to
learn from everything, to see the gifts of God and the generosity
of God in everything. It is to be thankful for all God's bounties.

This is the first step on the road to the love of God. This is just a
seed of love. In time, the seed will grow and become a tree and
bear fruit. Then, whoever tastes of that fruit will know what real
love is. It will be difficult for those who have tasted to tell of it to
those who did not.

Love is a special pleasurable pain. Whoever has this in their
heart will know the secret. They will see that everything is Truth,
and that everything leads to Truth. There is nothing but Truth. In
the realization of that they will be overcome. They will sink into
the sea of Truth.

Whatever you taste of love, in whatever manner, in whatever
degree—it is a tiny part of Divine Love. Love between men and
women is also a part of that Divine Love. But sometimes the
beloved becomes a curtain between love and realization of true
love. One day that curtain will lift and then the real Beloved, the
real goal will appear in all Divine glory.

What is important is to have this feeling of love in your heart in
whatever form and shape. It is also important that you be loved.
It is easier to love than to be the beloved. If you have been in love
you will certainly reach the Beloved one day.

The gifts of God often come to you from the hands of other human beings, through God's servants. And so, Divine love also expresses itself betweeen human beings. The sheikhs are the pourers of the wine and the dervish is the glass. Love is the wine. By the hand of the wine pourer, the glass—the dervish—is filled. This is the short way. Love could be offered to one by other hands. This is the short way.

* * *

Once one of my dervishes asked me if the love of a dervish for a sheikh was an example of worldly love. To understand truly the relationship between sheikh and dervish, you have to look not only at this world but also at the Hereafter.

On the Day of Judgment each soul will be asked what deeds it brought with it, what good deeds it has accomplished, to gain admittance to Paradise. On the Divine balance scale all our good deeds will be weighed against our sins and errors.

When your deeds are weighed and you are found lacking, as so many of us will be, you will turn to your husband or wife and ask if they can spare any good deeds to help your plight. Absorbed in their own judgment they will say, "What about me? I have not done enough to merit Paradise. Who will help *me?*" You will turn to your father, and he too will say, "*I* need help. Who will aid me?" Turning to your mother, you will ask her for help. And your mother, overcome with the shock of Judgment Day, will also say, "I am lost myself. Will anyone help *me?*"

Then your sheikh or one of your brother or sister dervishes will appear and say to you, "Take *all* of my good deeds. It is enough for me if *you* enter Paradise." Divine Compassion and Divine Justice will then intercede. Not allowing such generosity to go unrewarded, sheikh and dervish will be taken to Paradise.

And that is how we will go, God willing, hand in hand, each holding on to each other.

None of us may be truly worthy, but because of those who have gone before us and because of your love for each other, we

will carry each other to Paradise!

So, to answer the question, no, the love of a dervish for his or her sheikh is *not* an example of worldly love!

One of the great examples of love is the relationship between the Prophet Joseph (God's Peace upon him) and Zuleika, Potiphar's wife. Joseph was said to be more radiant, more handsome than any other prophet before him. Zuleika fell in love with Joseph the moment she saw him. Zuleika sacrificed everything for her love of Joseph—money, reputation and position. She was so crazy about Joseph that she would give her finest jewels to anyone who reported seeing him and told her what her beloved was doing. She became the scandal of the Egyptian aristocracy—a married woman shamelessly in love wih her husband's slave.

There is a deep truth here. This was not an ordinary love. Love so powerful has something forbidden, even illicit, about it. It can make you forget who you think you are. It can take you beyond the conventions and limits of your society. It can take you to Truth.

Once she heard that all the society ladies were gossiping about her, Zuleika paid them back. She invited her friends to lunch. For dessert she served fresh fruit along with sharp knives to peel and cut the fruit. Then she summoned Joseph. All the women were so struck with his beauty they forgot completely about the fruit they were cutting and cut themselves. Zuleika commented, "You see! Now do you blame me?"

Years later their stations in society were reversed. Joseph had become the Pharaoh's friend and closest advisor, the second most powerful man in the country. Zuleika had been cast out by her husband because of her scandalous love and was now reduced to earning a meager living through begging and menial labor.

Joseph saw Zuleika in the street one day. He was robed in silk, riding a beautiful stallion, surrounded by advisors and his own personal guard of soldiers. Zuleika was clad in rags, her beauty lost in the trials of her life of the past years. Joseph said, "Oh

Zuleika, before, when you wanted to marry me, I had to refuse you. You were my master's wife. Now you are free and I am no longer a slave. If you wish, I will marry you now."
Zuleika looked at him, her eyes filled with light. She said, "No, Joseph. My great love for you was but a veil between me and the Beloved. I have torn that veil aside. Now that I have found the Beloved, I no longer need your love."
Through her great love for Joseph, Zuleika found what we are all seeking, the Source of Love.

* * *.

In Istanbul, there is a beautiful mosque called the Beyazid Mosque. From the time this mosque was built, Sufi sheikhs and dervishes have always been present.
Sheikh Jemal Halveti (God's Mercy upon him), one of the sheikhs of our path, was invited by the Sultan to bless the opening of this grand mosque. The wise men of Istanbul, the aristocracy, and the Sultan himself were there. The cream of the Ottoman Empire was gathered that day.
When the sheikh got up to talk before this learned and sophisticated crowd, a simple-minded man jumped up. The man said, "Oh Sheikh, I lost my donkey. Everybody in Istanbul is here. Please ask them if they have seen my donkey."
The sheikh said, "Sit down. I will find your donkey." The sheikh then addressed the crowd, "Are there any among you who do not know what love is, who have not tasted love in any form?" At first nobody moved, but finally, one by one, three men stood up. The first man to stand up said, "It is true, I really do not know what love is, I have never tasted it. I do not even know what it is to *like* someone." The other two nodded agreement.
Then the sheikh said to the man who had lost his donkey, "You lost one donkey. Here, I am offering you three!"
But even a donkey loves fresh green grass. When people learn how to love—real, true love—their station rises above that of angels. When we do not know love, our station becomes lower than that of donkeys.

That reminds me of another donkey story.

Once, one of Jesus's apostles was preaching in a small town. The people asked him to perform a miracle, by raising the dead, as Jesus had done.

They went to the town cemetery and stopped before a grave. The apostle prayed to God to bring the dead back to life. The dead man rose from his grave, looked around him and cried, "My donkey, where is my donkey?" In life, he had been a poor man whose most cherished possession was his donkey. His donkey was the most important thing in his life.

The same is true for you. Whatever you care about most will determine what happens to you at resurrection. You will be together in the Hereafter with the ones you love.

DERVISH EDUCATION

THE great Sufi saint Ibrahim Ad'ham (May his soul be sanctified) was once the Sultan of Belkh. He abandoned the kingship of this world to become the king of the Hereafter.

His example illustrates that we may think that we are the ones who seek and who find, but this is not really so. It is God Who seeks us and then we respond.

At our level, we often don't accept God's invitation immediately. We wait. We consider and contemplate.

Ibrahim Ad'ham had considerations also. He wanted to be a dervish and to devote his life to find himself and to find God, but he had a lot to give up. He had to give up a whole kingdom, and give up the state of a sultan. The invitation was there—God was asking for him. But he wasn't ready to say, "Here I am, Lord." That is all you have to say, "I am here; I am present, at your orders."

Remembrance of God is one of the fundamentals of Sufi practices. To remember is, most simply, to say, "I am here. I am." Ibrahim Ad'ham was not capable of remembrance at this point. But God requested Ibrahim Ad'ham to come to Him.

One night the sultan was sleeping in his feather bed, with silk sheets and the finest blankets. In his heart there came the feeling, "I must go; I must leave this; I must." All of a sudden he heard strange noises on the roof of the palace. He opened the window and shouted, "Who is up there? What are you doing up there?" A voice came down and said, "We are plowing the field up here." Ibrahim Ad'ham said, "What kind of an answer is that? How can you plow a field on the roof of the palace?" The voice

replied, "Well, if you think that you can find God in your silken sheets and in bed, why not plow on the roof of the palace!"

You have to make certain efforts, and bear certain pains. God is nearer to you than you are to yourself. God has said, "There are seventy thousand veils between you and Me, but there are no veils between Me and you." God is nearer to you than you are to yourself.

If you don't think of God in this way, you can search the universe and never find God, like the Russian astronaut who looked for God outside his spaceship and said, "Oh, I haven't seen God up there."

He has to find God in himself.

Something which is so close to you is hard to see. It is too close. And something which is too far away cannot be seen either. Once some little fish came to a big fish and said, "We hear that there is an ocean somewhere. Will you please show us the ocean?" The big fish replied, "For that you will have to get out of the ocean."

So do you have to go out of the truth to be able to see the truth? Perhaps God, the Truth, will show Himself to you.

But there is nothing but Truth. So you can't get out of the Truth to be able to look at the Truth. Just as the fish cannot come out of the water to see the water.

God says, I am closer to you than your jugular vein. God is that close to you—within you and completely surrounding you. Everything around you is God. You are like a fish in the sea. You cannot see God unless God chooses to be visible to you. And God will become known to you in a way that is different from the experience of anybody else. So you will never be able to convey fully your experience to another.

God Most High, Who does not fit into all the earths and heavens, has found a place in the heart of the believer. The experience of God comes from your heart. God will appear to you according to your potential, according to your capacity. It is different for each of us.

On another occasion, Ibrahim Ad'ham went out for a picnic.

Food was placed in front of him, and a crow swooped down and took his bread. The Sultan asked his men to follow the crow. They got on their horses and followed the crow, until it came to a man who was tied to a tree. The crow put the bread in his mouth. The soldiers reported this to the Sultan, who then went to the bound man and asked, "Who are you? What happened?" The man replied, "I am a merchant, and bandits took everything I had. I have been tied up here for days. Every day this black bird has brought food and put it in my mouth. When I am thirsty a little cloud appears and rains right into my mouth."

As Jesus (God's Peace upon him) has said, look at the birds. They go out in the morning and God gives them their sustenance. Then, they return to their homes at night. They do not do anything for their own sustenance. Here, God showed Ibrahim Ad'ham that it was not necessary to be tied to his sultanate, to this world. His sustenance would be given to him by God.

Jesus gave up the world. He divorced this world completely. Finally all that Jesus possessed were two items—his comb, which he used to comb his beard, and his cup, which he used to drink water.

One day he saw an old man combing his beard with his fingers, so Jesus threw away his comb. Then he saw another man who was drinking water from his cupped hands, so he threw away his cup.

As long as you do not divorce the world and the worldly, you are not going to meet your God. You must be very careful here. Jesus is an example of this total giving up of the material world. On the other hand, you have the great prophet King Solomon (God's Peace upon him). He was the richest of the rich, and the most powerful, both of this world and of the hereafter. The prophet Solomon was the king of humans, jinn, animals and elements. The world becomes a veil between you and God as long as your heart is attached to your possessions. If you have everything you desire, but can do without—that is fine. On the other hand, if you have nothing but a fish head and you are attached to that piece of fish, then you are attached to this world.

It is a question of divorce by the heart. Material poverty is not necessary.

Ibn Arabi (May his soul be sanctified), considered the "Greatest Sheikh" in Sufism, met a devout and ascetic fisherman in his travels in Tunisia. The fisherman lived in a mud hut. Every day he took his boat out to fish and he would distribute all he caught to the poor, except for a single fish head which he boiled for his own meager dinner.

The fisherman became Ibn Arabi's dervish and eventually became a sheikh himself. When one of the fisherman's dervishes was about to leave on a trip to Spain, the fisherman asked him to visit his sheikh and to ask Ibn Arabi to send him some spiritual guidance, because the fisherman felt he had not been making any spiritual progress for many years.

When the dervish came to Ibn Arabi's home town he asked where he could find the great Sufi sheikh. The townspeople pointed out a palatial mansion on top of the hill and told him that was the sheikh's home. The dervish was shocked at how worldly Ibn Arabi must be, especially compared to his own beloved, simple fisherman sheikh.

Reluctantly he made his way to the mansion. On the way he passed cultivated fields, beautiful orchards, and herds of sheep, goats and cattle. Each time he asked he was told that the fields, the orchards and the animals all belonged to Ibn Arabi. The dervish asked himself how could such a materialist be a Sufi sheikh.

When he reached the mansion the dervish's worst fears were confirmed. Here was wealth and luxury beyond his wildest dreams. The walls were made of inlaid marble. The floors were covered with priceless carpets. The servants wore silk. Their clothing was finer than that of the wealthiest men and women of the dervish's home village. He asked for Ibn Arabi and was told the master was visiting the Caliph and would be back shortly. After a short wait he saw a procession coming toward the house. First came an honor guard of the Caliph's soldiers, with brightly shining armor and weapons, mounted on beautiful Arabian

horses. Then came Ibn Arabi, dressed in magnificent silk robes and a turban fit for a sultan.

When the dervish was brought to see Ibn Arabi, beautiful serving girls and handsome serving boys brought them coffee and cakes. The dervish relayed his sheikh's message. He was shocked and indignant when Ibn Arabi told him, "Tell your master his problem is that he is too attached to the world."

When the dervish returned home, his sheikh eagerly asked if he had met the great sheikh. Reluctantly, the dervish admitted that he had. "Well, did he give you any advice for me?"

The dervish tried to avoid repeating Ibn Arabi's remarks. They were so incongruous considering Ibn Arabi's opulence and his own sheikh's asceticism. Besides, his sheikh might be offended at him for repeating such things.

The fisherman insisted, and finally the dervish told him what Ibn Arabi had said. The fisherman broke into tears. His amazed dervish asked how could Ibn Arabi, living in such luxury, dare to tell him he was too attached to the world. "He is right," the fisherman said. "He really cares nothing for all that he has, but every night, when I have my fish head, I wish it were a whole fish."

* * *

Every prophet has a specific duty. The role of Jesus Christ was to exhibit the lack of worldly possessions and concerns.

The words and actions of the prophets and the beloved of God are not their own. They no longer have their own will. They express only God's will. Even lesser saints reach a similar stage. What they see is seen with God's eyes. What they hear is heard with God's ears. What they say is said with God's tongue. They walk with God's feet and grasp with God's hands.

That is how Jesus did not have his own will. He was the expression of God's will for a specific function and purpose, and this is possible even for ordinary—well, not so ordinary—people who love God and are loved by God.

In Solomon, God's will manifested itself with property and power. Jesus became the sultan of the heart and the spirit, while Solomon combined worldly and spiritual rule.

If you are a sultan of this world, people will not be content or in accord with your rulings. It is very difficult. Moses (God's Peace upon him) complained to God, "I'm trying to work for you but everybody is talking against me." God replied, "Moses, you are only flesh and blood. I am their Creator. I am their Sustainer. And they talk against Me too!"

That is why God remains hidden, at least from most of us. (Some of us even today, still see God!) Could you imagine if God was visible, as the prophets were? We would go running to God, crying, "Look, I don't have any children. I don't have enough money. I lost my job." Others would say "I'm not content with Your justice!" That is why God has hidden—to find peace and safety. At least God has hidden from the complainers.

You see, to come back to our story, human will is very limited. Do not fool yourself saying that *you* are seeking and that *you* will find. Ibrahim Ad'ham was called by the Truth. But he had to be taught by the man plowing on the roof of his palace, and by the crow who fed the bound man. But do not forget, you have to see these signs. Looking is not enough; you have to see. Hearing is not enough; you have to understand.

Finally, one day Ibrahim Ad'ham left his palace and took to the fields. He met a shepherd in tattered clothes. Outside were rags, but the shepherd had found God in the solitude of the fields. His insides had become rich and beautiful. Although the sultan wore silk, his insides were tattered, because he had not found the truth. Ibrahim Ad'ham asked the shepherd to exchange clothing, and they did.

The Sultan turned his back to the world. His kingdom, wealth and power, his clothes and his rank were the veils between him and God. He tore them off and threw them away. Of course, he had to have these things first, in order to be able to give them up.

And he went where he was told.

Ibrahim Ad'ham was led to a sultan of truth, his sheikh, his

teacher. Under his master's order, Ibrahim Ad'ham began the greatest combat, the combat with his ego.

In his education as a dervish, Ibrahim Ad'ham's sheikh gave him the task of wandering in the world, to see where he came from.

In this kind of training, you read a book for the first time and understand certain things. Then, you read it again and understand something else. You read it a third time and find still more. The sheikh sent Ibrahim Ad'ham to read the book of his previous life, so he could understand it at a higher level.

The greatest book is this world, this life. Read it and reread it. Your past is the greater part of this book. As you keep rereading it, you will find it changed, and you will find yourself. It is a vast book, reaching from this earth to the farthest corner of the heavens.

Ibrahim Ad'ham arrived back in Belkh on a cold winter evening. He made his night prayer in the Grand Mosque which he had built when he was sultan.

Night is very important for the seeker. The time for night prayer comes about an hour or so after sunset and continues until about two and a half hours afterwards. After finishing their devotions to God, some people go home to be with their beloved. They look into the eyes and smell the hair of their beloved. That is also devotion—loving one's wife and children. And the great saints and prophets often devoted themselves to prayer and devotion at night.

After Ibrahim Ad'ham made his night prayers he had nowhere to go. He said to himself, "This is a house of God and I built it to be open to everybody. I'm going to find a little corner to sit and meditate and rest."

The caretaker of the mosque came in. Recently a thief had taken a carpet from the mosque. The caretaker found the ex-sultan, now a dervish, and said, "Aha! You are the carpet thief hiding here to steal another carpet." He dragged Ibrahim Ad'ham by the feet and pulled him down the hundred steps of the mosque. Ibrahim's head hit each step. And all the way down,

with each pain, Ibrahim Ad'ham thanked God. When he reached the bottom of the steps, he said to himself, "Ah, if I only had made more stairs."

Because of his submission to Divine Will, for each moment of suffering, his spiritual level rose. Because Ibrahim Ad'ham had left this world, he had left the pains of this world. Yet you have to suffer the pains of this world for your spiritual level to rise.

All scriptures say we are brought to this world to be tested. You can find this in the tradition of Moses, in the tradition of Jesus, and in the tradition of Muhammed.

But what is testing? A teacher tests students to determine their abilities, the level of their knowledge. The teacher does not know how much the students have learned. But doesn't God know? God knows perfectly our abilities, our knowledge, and our level of consciousness. The reason for God's tests is to make *us* know. Tests show us where we are, and let others know where they are, through both our tests and theirs.

The ones who suffer the worst trials are the beloved of God—the prophets, the saints, and God's teachers. They are visible symbols of humanity, whose job is to show others our purpose on earth.

Eventually, Ibrahim Ad'ham passed almost all the tests set for him by his teacher, and he returned to the city where his sheikh lived. Before he arrived, the sheikh spoke to the rest of his dervishes. You see, sheikhs know when things come and go, within themselves and outside. The sheikh told all his dervishes to go to the gates of the city. "When you see Ibrahim Ad'ham returning, don't let him enter. Hit him, kick him, spit at him, beat him, make him stumble." When Ibrahim Ad'ham came to the city gates, his brothers did many cruel things to him. He went to another gate and his brothers there abused him just as badly. He went to the third gate and was met the same way. Ibrahim Ad'ham said, "Look, no matter what you do to me—you may shed my blood and try to kill me—nobody is going to prevent me from reaching my sheikh."

When finally he managed to pass through the gates, all the

dervishes continued to kick at his heels, until he reached the sheikh's home. The dervishes kept kicking him and kicking him and kicking him. Ibrahim Ad'ham said nothing. He just continued going toward his sheikh. Then, one young, enthusiastic dervish kicked him so hard that the skin on the back of his heel was torn off. Ibrahim Ad'ham turned and said calmly, "Why are you doing these things to me? Don't you know that I am your brother? I'm a dervish also. Do you still take me for the sultan of Belkh?"

The dervishes reported this to the sheikh, who said, "You see, he hasn't yet reached the highest level. He hasn't forgotten what he once was. The taste of the sultanate, the taste of the power of the king is still in the palate of his mind and his memory."

* * *

For many years Ibrahim Ad'ham continued to travel, begging for his food, learning from the world, and teaching by example.

A man once wished to give him some money. He said, "If you are rich I shall accept your offer, but not if you are poor."

The man assured Ibrahim Ad'ham that he was indeed very wealthy.

"Just how much money do you have?"

"I have five thousand gold pieces."

"Do you wish you had ten thousand?"

"Yes, of course."

"Would you prefer twenty thousand?"

"That would be wonderful."

"You are not really rich at all! You need this money more than I do. I'm satisfied with whatever God gives me. I couldn't possibly accept anything from someone who is always yearning for more."

* * *

One day Ibrahim Ad'ham tried to enter a public bath. The bath attendant stopped him and asked for the entrance fee. He hung

his head and admitted he had no money.

The attendant replied, "If you have no money, you can't enter the bath."

Ibrahim Ad'ham cried out and sank to the ground, weeping bitterly. Passersby stopped to comfort him. Someone offered him money so he could get into the public bath.

Ibrahim Ad'ham said: "I'm not weeping because I was refused entrance to the bath. When the bath attendant demanded an admission fee I was reminded of something which led me to weep. If I am not allowed to enter the bath in this world unless I pay the fee, what hope do I have of being allowed to enter Paradise? What will happen to me when they demand, 'What good deeds have you brought? What have you done worthy of being let into Paradise?' Just as I was kept out of the bath because I could not pay, I will surely be kept out of Paradise if I have no good deeds to my credit. That is why I weep and moan."

As they reflected on their own lives and deeds, all his listeners began to cry with Ibrahim Ad'ham.

* * *

When Ibrahim Ad'ham visited the city of Basra, the people of the city asked him, "Although God says, 'Call upon Me, and I will answer your prayers,' our prayers are never answered." Ibrahim Ad'ham replied, "Your hearts are dead because of ten bad qualities. God does not accept the prayers of those whose hearts are dead." Then Ibrahim Ad'ham listed their ten failings:

1. You pretend to acknowledge God, yet you do not give what is due to God. Try to repay what you owe God by helping the poor and needy.

2. You read the Holy Qur'an, but you fail to observe its teachings. Practice what you read.

3. You claim that Satan is your enemy, yet you obey him. Refuse to follow his suggestions.

4. You call yourselves members of the Community of Muhammed, yet you do not even try to follow the example of the Prophet.

5. You say that you wish to enter Paradise, yet you fail to perform those deeds that you know are needed to gain admittance.

6. You wish to be saved from the Fire, yet you continually throw yourselves into it by your sins and bad deeds.

7. You know that death comes to all, yet you have made no preparation for it.

8. You see all the faults of your brothers and sisters in religion, yet you fail to look at your own faults.

9. You consume all you have received from your Lord without giving thanks and without showing your gratitude by feeding others.

10. You bury your dead without learning the great lesson that the same end will come to you also."

The prophets and saints are like mirrors; just as the mirror shows us the dirt on our faces, so do holy men and women show us our faults.

An old saying goes, "Clean your face instead of blaming the mirror." But most of us would rather break the mirror than give up our bad habits.

Ibrahim Ad'ham's teachings opened the eyes of his listeners. They also hold for us today, and for all believers until the Day of Resurrection.

FAITH

IN the early years of Islam, many thoughtful people whose ancestors had worshiped idols or fire came to question their ancestors' practices. There were two fire-worshiping brothers who felt this way. One brother suggested that they put their hands into fire. If it burned, they should stop worshiping it and embrace Islam. So they prayed to fire, asking the god of their ancestors not to burn them. When they put their hands into the fire, it burned.

The first brother said he was going to investigate Islam. The second brother backed out, saying he wasn't ready to abandon the religion of his culture and his ancestors.

The first brother went to the nearby mosque. He was amazed and delighted to see everyone praying together, without any distinctions of class or caste. Slaves stood next to men of power and influence. Rich and poor were intermingled. The fire-worshiper's heart was moved by the truth of the scriptural passages read and by the views of God expressed by the teacher. He got up at the end of the prayers and expressed his intention to embrace Islam. The assembled congregation was touched and overjoyed by his sincerity. As he was obviously a poor man, several of the wealthier believers offered to loan him money or give him a job. The man refused all offers of help, saying that God had helped him even when he was an unbeliever, and surely now that he had come to faith he could continue to rely on God.

The man returned home and told his wife about all that had occurred. She was overjoyed to hear of her husband's new faith

and agreed to embrace Islam as well.

The man left home to seek work. He was a porter who carried heavy loads for a living. But no one had any work for him. When noon came, he went to the mosque for prayer. Again, he refused offers of help from fellow believers. He prayed to God to provide for him and his family. But that afternoon there was still no work to be found. Finally, that night he returned home. Rather than disappoint his wife and children, he told them that he had found a job with a wonderful master, but his new employer had left early and forgotten to pay him. They had a meager supper made up of what little food was left in the house.

The second day went just like the first. The man simply could find no work, no matter how hard he tried. At each of the times for prayer, he went to the mosque and prayed to God to provide sustenance for his family. That evening, on the way home, he picked up some scraps outside an inn and brought them home to relieve his children's hunger. He told his family that his master had once again forgotten to pay him.

On the third day, there was still no work. He prayed deeply at noon for his family. He saw this situation as a test of his faith and resolved to do nothing but pray and seek work until his family was provided for.

That afternoon a radiantly handsome young man came to his house and handed a bag of gold to the wife. He said, "Tell your husband that his new master is well pleased with him." Opening the bag, she cried, "Oh, what a wonderful, generous master!" She had never even seen a gold coin in her life before. Here was enough money to support the whole family for the rest of their lives.

The wife took one coin to the moneychanger. When he tested the coin, the moneychanger asked where she had gotten it. "I have never seen such absolutely pure gold. I cannot imagine where on earth it could have come from."

The man was unable to find work all that day. Tired, hungry and dejected he set off for home. He was worried about how disappointed his wife and children would be. On the way home

he stopped and filled two large kerchiefs—one with sand and the other with stones. "At least, my neighbors, who have all heard of my new faith, will not gossip about my returning home empty-handed for three days in a row."

When the man came to his house, he saw lit candles in all the windows and smelled meat and vegetables cooking. He threw open the door and saw his wife and children in their best clothes, several pots of food bubbling on the fire. Upset, he asked his wife, "Did you borrow money from someone? Where did you get all this food and these candles?"

Happily, his wife told him that a messenger had come from his new master and given them a bag of pure gold coins. The man threw down his two bundles behind the door and embraced his happy family. Then his wife reprimanded him for throwing food on the floor. He turned and found that the sand had turned into the finest flour and the stones had turned into fresh baked bread! We are also sustained by God. We are as well paid, only we rarely realize it and are rarely grateful.

* * *

Superficially, it seems that science and materialism have become obstacles to faith in this modern world. However, we must be careful to distinguish two kinds of faith. There is blind faith, where one simply says, "I have faith. I believe in God." There is also real faith, which is not just a belief. It is faith which is expressed in action.

Even if you do not say "I believe," your actions will express your faith. There are even some people who will deny their faith with their mouths, but not with their actions. They are faithful through their science and through their art, though they may even say "I don't believe" with their mouths.

Such people confirm their faith in their actions, in their way of life, in their creative discoveries. Superficially they seem to be doubters, agnostics, but they are really people of faith.

Whether that kind of faith is acceptable to God or not is not for

us to say. Who knows? Only God knows. I certainly haven't spoken to God about whether our faith or the doubters' faith will be accepted by Him.

Some people claim that these are difficult times for humanity, but I don't think so. The times are not bad. Some people are bad perhaps. The moon, the sun, and the stars have not failed in their duties. The seasons appear and disappear just as they always have.

Real men and women don't change. They finally find themselves and they turn toward God. By real men and women I mean the truly human beings. I am not talking about animals who appear in human shape. I am talking about those who are human, as humans are meant to be.

I have seen many who have appeared to be sinners and evil, bad people, who have become wonderful examples of real human beings. You have seen wild animal trainers in circuses, who educate elephants, tigers and lions. Each of us has a treasure hidden within. Whenever you see this treasure which is in yourself—and after all, you are not a tiger or a lion or an elephant—when you find this inner treasure, then you will become a real human being.

We might pray that the number of teachers and masters increases, and that people become their own teachers and find this treasure in themselves. When people are contemplating an evil act, intending to carry it out, and realize that they are being watched, that evil intention will disappear in them.

Why has God sent us teachers and prophets since the very dawn of humanity? If that treasure, that potential, was not in us, why should God take the trouble of sending teachers and prophets to help us find it?

As long as the word of God comes from our lips, the Last Day will not come. What is the meaning of this? As long as there is a single person who believes in God and says God's names, then the Last Day will not come. But that is not saying "God" like saying "Hello."

Those who say "God" must know that humanity is divine. We

are all divine. We belong to God. We are neither the before nor are we the after. We are a part of truth. When that is forgotten, when that remembrance is erased from our heads, then we are in danger. But that has not happened.

Today, on the face of the earth, are there more men and women who believe in God, or are there more who do not believe? God wants us to find Him, to know Him. And the Devil wants us to forget and to lose God. Who are in the majority, the followers of God or the followers of the Devil?

If we say that there are more followers of the Devil, that means that the Devil has more power than God. By this criterion, you can see that the faithful must be in the majority. There are many who think that they deny God, or the existence of God, but their actions are actually those of believers.

In materialist countries, there are many hiding their faith. In democratic countries we believe we are free in expressing our faith. But in countries under the fist of tyranny, in spite of oppression, many have to hide their faith, yet they remain faithful.

Look at Turkestan in Russia, for instance. There is an Islamic ritual of sacrificing a lamb, in commemoration of Abraham's sacrifice of a ram in place of his son. Under the Communist regime, the people are forbidden to celebrate this ritual. In spite of that, devout Muslims go and steal lambs from the collective farms in order to carry out this religious sacrifice. They risk their lives to do it. Although stealing is sinful, they will steal to carry out their religious duty.

In Viet Nam, for instance, you may remember how many Buddhist priests poured gasoline over themselves and burned themselves. This is obviously not something that is pleasant to hear about, or to see or feel. But look at the extent of their faith. Those priests were willing to purify themselves, to sacrifice themselves in this terribly painful way. To commit suicide is a very ugly thing, but these Buddhists did it for the sake of their faith.

In our times, the majority of people are believers. And, in any

case, the future is for the believers. Those who act—who are permitted to act—are the believers. There is God, our Creator. The faithful are those who are able to act, who are able to perform, who are able to function.

SELF KNOWLEDGE

GOD says, "Those who purge themselves of their *nafs* will find salvation." The *nafs* is not a thing. The Arabic term is related to words for "breath," "soul," "essence," "self," and "nature." It refers to a process which comes about from the interaction of body and soul. The body is composed of "clay," a combination of material elements. The soul comes from God. It has seven aspects or levels—the mineral soul, the vegetable soul, the animal soul, the human soul, the angelic soul, the secret soul, and the soul of the secret of the secrets.

Certain elements of the soul can be improved. The medicine for this can be found in the holy scriptures and in the teachings of the prophets and saints.

How could the soul have any negative or undesirable qualities? After all, it is not of this earth but comes from the level of the Throne of God.

The soul becomes an exile when it enters the body. It becomes imprisoned within the body. Our bodies contain many different organs and instruments of action, for example, our sexual organs, but the body itself does not contain the psychic power to fulfill our physical urges. The soul contains the power, but not the means of action.

When the soul puts these bodily instruments into bad usage, *then* we can speak of undesirable qualities of the soul. God has created nothing which is bad. It is our misuse of things which becomes bad. For example, sexual desire is normal and necessary to propagate the species. It also provides a way of expressing love between husband and wife. However, when this natural

desire is turned into lust, it can lead to all kinds of harmful actions.

So, which is responsible for our bad acts—the body or the soul? It is said that on the Day of Judgment the body will blame the soul, saying "*I* had no power to act." The soul will then try to blame the body, saying "I had no means to act." They will be answered with the parable of a strong blind man carrying a cripple on his back. The cripple possesses both sight and judgment, and directs the movements of his blind bearer. Which is responsible? Both are guilty.

The *nafs* is not bad in itself. Never blame your *nafs*. Part of the work of Sufism is to change the state of your *nafs*. The lowest state is that of being completely dominated by your wants and desires. The next state is to struggle with yourself, to seek to act according to reason and higher ideals and to criticize yourself whenever you fail. A much higher state is to be satisfied with whatever God provides for you, whether it means comfort or discomfort, fulfillment of physical needs or not.

All of these levels of *nafs* are part of the created world. They are imprisoned in the body, exiled from their home.

The highest level of the soul, the pure soul, is not a part of creation. It is an aspect of the Divine Attribute, *al-Hai*, The Everliving. You cannot locate it either inside or outside the body. The other levels are located within the body, but the pure soul is a part of the Infinite. As such, it cannot be contained within all of creation. It is a direct manifestation of The Everliving.

The *nafs* contains the dispositions or qualities of the embodied soul.

God said, "We blew into Adam with Our own breath." This is the soul which remains imprisoned in the body until we hear the words at death, "Return to your Lord." The lowest levels of soul remain within the body. They do not want to leave at death. They rebel because they have become attached to the body.

What about the souls of the great prophets and saints? They are, in fact, different from the rest of us. They are more pure. The earthly, material elements of these great human beings are taken

from the most holy, sacred spots on earth. Their bodies are pure and when the soul enters such bodies it is not defiled in any way. There is a famous saying, "He who knows himself [literally, "He who knows his *nafs*"] knows his Lord." There are two meanings to this. The first is that we can come to know our needs, desires and weaknesses, and also come to realize the existence of a majestic power. Then we know that we need a protector—someone who feeds us, clothes us and shelters us in this world. The second is a mystical explanation. God said, "I am closer to you than your own jugular vein." In knowing ourselves we will discover this deep connection with our Lord. By following this cord we can reach God.

This path back to God can be followed only by those who live according to God's commandments. Those who don't, who choose to follow Satan instead, will be separated.

There is something which unites us to God. Although God is above all similes, it is like the existence of millions of individual light bulbs yet there is but one thing called electricity. Each bulb differs. Some are 10 watts and others are 100 watts. The power behind them all is the same. Or think of a bunch of grapes. They will rot quickly if plucked, but will live if they are left on the vine. Something comes to each grape through the vine.

Everything is the same, everything is beautiful in essence. Only the superficial attributes can be ugly.

Do not be attached to this world. Separation from everything of this world comes with death. Before you die you will hear the order, "Return to your Lord." All attachments to the world will leave and you will find unity with God.

King Solomon (God's Peace upon him) was the wealthiest and most powerful ruler and also the greatest prophet of his age. Although he had great power and inconceivable wealth, his possessions were of no concern to him. He considered them nothing but a burden and a source of trouble.

Every day he visited his parrot. One day the parrot was very sad. The bird had become homesick for his native land.

Speaking of parrots, one parrot who had an amazingly large

vocabulary was auctioned in Istanbul for $2,000. When Nasruddin (who often taught through humor) saw this he was amazed. The next day he brought his big, ugly turkey to the market. The best offer he received from the crowd was $6. He cried to the crowd to bid higher, because his bird was much bigger than the bird that sold for $2,000. Someone shouted, "*That* was a fine *parrot*, and can talk just like a man!" Nasruddin replied "This is a fine turkey and can *think* just like a man!"

King Solomon granted his parrot leave to return home. The journey took one month to go and one month to come back, so Solomon gave his parrot three months' leave. He warned the parrot to come back on time or else he would send the winds or the jinn after him.

The parrot returned home and had a wonderful reunion with his family and friends. Time went by very quickly. As you know, a night can seem but a moment for two lovers, yet for someone with a toothache, a night can seem endless.

As the parrot was about to leave, his family offered him a bottle of water of eternal life as a gift suitable for King Solomon. The parrot tied the bottle to his right wing and flew back. He presented the bottle to Solomon.

The prophet consulted his advisors. He asked if he should drink the water of eternal life. All the court—humans, animal and jinn—said, "Yes. We want you to be our ruler forever." Except the owl, who said, "Before you drink, visit a certain cave and see who is there."

Solomon went to the cave and there he found an old man who was praying for death. The owl told the prophet that this man had tasted the water of eternal life and could not die.

Be ready to go when your time has come. No one really wants to endure endless illness and disability. And there is no greater pain than seeing your children die and being left alone.

As Solomon stood, not knowing what to do with the bottle, the angel Gabriel came and knocked it over.

THE HOLY QUR'AN

THE Holy Qur'an is in Arabic, but in essence and in actuality it is written in the language of God. Only those who love and fear God can understand the real meaning of the Holy Qur'an, only those who are close to Him, who understand His language.

To think that a book we can hold in our hands is the Holy Qur'an is to think the sun is a small round mirror. Human language is not sufficient to translate into human understanding the language of the Qur'an. We are temporary, but God is eternal.

The Qur'an is inexhaustible. If the seas were ink, if the forests were pens, the heavens and earth were paper, and until the end of time all creation would write this book—then the ink would run out, and the pens would end, there would be no more paper, the angels and all living creation would be exhausted—and the meaning of the Holy Qur'an would still not be fully explained.

Everything is included in the Qur'an—what is before time and after time, the hidden and the open. Whatever exists is in the Qur'an. However, you have to have eyes to see, ears to hear, a mind to understand and a heart to feel this.

The degree of your understanding of the Qur'an equals the degree of your closeness to God. The great Sufi saint and philosopher Ibn Arabi (May his soul be sanctified) once fell down from his horse. When his concerned students reached him, they found him sitting on the ground, motionless, lost in contemplation. Ibn Arabi looked up and told them, "I was just meditating on where in the Qur'an it was written that I would fall from my horse. I discovered it in the opening verse."

The Holy Qur'an is a document. It confirms all the other scriptures and the Messengers who brought them. At one level it shows the history of humanity, the history of the believers and the non-believers. It shows the rewards of the believers and the punishments of the unbelievers. It invites us to submission and to love.

The Holy Qur'an teaches us to be human beings. It teaches what is lawful and what is unlawful, and what love is. It is an eye given to us by God. Whoever possesses this eye sees what is right and what is wrong, what is evident and what is hidden.

The Qur'an was revealed to the Prophet (God's Peace and Blessings upon him) piece by piece, over a period of twenty-three years. When each portion was revealed to him, the Prophet would lose himself. On bitter cold evenings he would perspire.

God revealed to him that if this message had descended on a mountain, the mountain would have been flattened. But human beings are stronger than mountains. His Companions witnessed that when a revelation of the Holy Qur'an came to the Prophet while he was on his camel, the camel fell on its knees with the weight of the message.

The cleansing of the dirt of the world is mentioned in the Qur'anic description of the birth of the Messenger Jesus (God's Peace upon him). His immaculate conception was a heavenly gift. The Qur'an tells us that he was the messiah and tells us of his raising the dead, curing leprosy and healing the blind.

The Holy Qur'an is a book of lessons, a book of truth, a book of love. It teaches us the qualities of the prophets. It shows us that we are God's representatives here on earth. You cannot let it leave your hand, or your mind, or your heart. To read any other book constantly would be boring, but not this book. The more you read, the more you want to read.

One of the miracles of the Qur'an is that a child of five can memorize it. It consists of 114 verses, 6,666 lines. No other scripture can be so easily learned. In every century there have been thousands, hundreds of thousands who have memorized the Holy Qur'an.

Human beings are temporary, the book is eternal. It is the book of God. Then how could anyone memorize the Qur'an? How could temporary humanity even dare to read the eternal Qur'an? It is God who protects and keeps the true Qur'an—word by word, dot by dot. It is the human heart which memorizes it, but it is actually God who keeps this Divine book in human hearts. It is God who recites the Holy Qur'an through human lips.

The Holy Qur'an is not a book written in Arabic. The whole universe is the Qur'an. It is from before the before, to after the after. It is the explanation which includes everything.

The lovers of God recite the Qur'an. Those who are sincere and whose hands hold onto their Creator understand the meaning of the Qur'an. The Qur'an is like a rope. One end is in the hand of the power of God, the other descends to this world. Whoever holds onto that rope is safe, and will receive the pleasure of the Truth and Paradise.

Read the Holy Qur'an so that you can find the cure to all your troubles.

After the passing of the Prophet, his wife Aisha (May God be pleased with her) was asked to describe him. She said that if you want to know him, just read the Qur'an, because he was the living Qur'an.

The Prophet Muhammed said the following about the first revelations of the Holy Qur'an:

After I reached the age of thirty, I was made to love loneliness. I was made to love seclusion in the mountains of Hira, near Mecca.

One day the angel Gabriel came to me. He had the form of a man and was extremely beautiful. Light came from him. I stood up and walked to him. He told me, "Read!" I replied I did not know how to read. He grabbed me and hugged me so hard my bones were crushed. Again he repeated, "Read!" Again I replied I did not know how to read. Once again he embraced me and pressed me to him. Once again he bade me, "Read!" I repeated a

third time, "I do not know how to read." Again he embraced me and hugged me so hard my bones were crushed.

Then the first revelation came to me: "Read, in the name of God, Who creates.

"Read, in the name of God, Who created humanity from a blood clot.

"Read, in the name of God, Who is generous, Who taught humanity by the pen, Who taught humanity what they knew not."

I was shivering. I began to hurry down the mountain. Then there came a sound from the Heavens to my ears. "Oh Muhammed!" When I lifted my head and looked toward the heavens, the body of Gabriel had grown so large it covered the sky from East to West.

Running, I returned to my home and my wife Khadijah. I was still shivering. I said, "Cover me, cover me. I saw what I saw, but what did I see? Was it a jinn or a hallucination, or was it a revelation of the Truth?"

Khadijah replied, "No hallucination would come to you. No jinn would come to you. You are one who is merciful to others. You keep your word. You wipe the tears of those who cry. You are the caresser of orphans. How could jinn appear to such a beautiful and generous man? That which you have heard and seen is from Heaven, from God. I have dreamed that I was going to marry a Prophet, the last Prophet, who would come after Jesus. Now it has come true."

Later, I was sitting alone wrapped in a heavy robe and the angel came to me again. He said, "O, the one who covers himself! Get up and bring the fear and love of God to your people, with God's greatness and power. Invite them to God. Give them the news of the justice for those who deny God. Remember God, invoke God, and pray to God. Order cleanliness and purity. You are pure. Teach purity, so that all humanity will be clean, both within and without, that all humanity will adorn themselves with faith. The human heart is the place of God."

That was the second revelation which came to Muhammed.

The holy book which resulted from these revelations brings fear to the hearts of deniers and unbelievers. But underlying this is always mercy and compassion. If a father tells his children to do something or else he will punish them, would he be happy if he actually has to administer the punishment? And the love of a father is limited, while God's love and mercy are infinite.

The fear which God inspires in the hearts of unbelievers is far outstripped by God's Compassion. God's Compassion far outweighs God's Wrath.

Those who are sincere, faithful believers are promised great rewards. The promises of both reward and punishment are all contained in that magnificent well of mercy, compassion and love which is the Holy Qur'an.

DREAMS

DREAMS can be very valuable on the Sufi path, because they often carry important messages. There are two kinds of meaningful dreams. The first is the truthful dream which carries a literal message. The second is the symbolic dream, which needs to be interpreted.

Dreams are also a means of communication between the Creator and humanity. This is true for everyone. It is not a question of belief in dreams or not, or even belief in God or not.

Dream interpretation is an important tool in many mystical teaching systems. For the dervishes dreams are significant indicators of their spiritual state. It is important for both the sheikh and the dervish to know of changes in the dervish's spiritual state. When your level changes, your duties change and your prayers change.

Animals dream also. There is a Turkish proverb that the hungry chicken sees itself in a bin filled with corn.

In the lives and the teachings of the prophets, dreams are often given great importance. In fact, another way of looking at the revelations of the prophets is that these revelations are pure, or purified dreams. Do not confuse that kind of dream with the dreams of ordinary people, and certainly not with the hungry chicken dreaming of corn.

How do dream images occur when there is no eye which sees? The eyes are closed in sleep. The retina is not functioning; the lens is not functioning. There is no eye which sees the dream, and there is nothing in front of the eye which is being seen. So what is it that sees, and what is seen in the dream?

What you see is really in the realm of divine knowledge. That which is hidden from you is known only within the realm of the divine knowledge of God. So how then are you supposed to see this and understand this, which is outside your scope of knowledge, in another realm?

All knowledge is contained in the realm of divine knowledge. All that is, all that was, and all that will be can be found in the realm of divine knowledge. As things pass into existence from that realm, whatever is about to occur is reflected upon a divine screen. It is written on that screen.

At sleep, the soul comes out from the body, without losing its connection to the body, like the beam coming from a flashlight. This light extends to that divine screen and "reads" those entries that pertain to it. In waking up, the light of the soul comes back into the body, as in shutting off the flashlight. Through the extension of the soul, you, the dreamer, can perceive a level of knowledge which is not within your realm. This knowledge is still within the divine realm.

Dream symbols and images are like hieroglyphics which can be read by those who are knowledgeable. But these symbols change from situation to situation, from person to person, from soul to soul.

There are seven different souls in each person: the mineral soul, the vegetable soul, the animal soul, the human soul, the angelic soul, the secret soul, and the soul of the secret of secrets. The dream symbols are different depending on the soul they pertain to, the soul that perceives them, and the person who sees them. The sultan may dream the same images as a slave, but it does not mean the same thing.

The various souls in the human being are not distinct from each other. They are within each other and each evolves toward higher souls. Finally, all these souls are unified in the human soul, or in one of the higher souls.

The level of soul that sees dreams is very important. The dreams of the animal and vegetable souls fulfill desires and impulses. For example, if you are hungry, you will dream of

eating. The human soul sees symbols. A snake may represent possessions, or, in the case of a dervish, it may represent a level of the lower self.

If the highest level of soul has left the body, the dream visions are direct. This level of soul can go to the Throne of God, read the Book and see clearly what will happen. The person may see accurate pictures of events in the United States, or in Istanbul or Japan. Also, these dreams are remembered clearly afterwards.

The sheikh interprets dreams through inspiration. The sheikh must know the station and the spiritual rank of the dreamer to interpret dreams correctly. Then, God sends the answer to the sheikh's heart. Some sheikhs can also give a good interpretation to a bad dream, which will then come out well. God makes the interpretation become true.

A dream should be told only to the dream interpreter. This secrecy is very, very important. The meaning of the dream is revealed to the interpreter as the dream is told.

You should never tell your dreams to someone who is in the habit of speaking ill of others. Tell your dreams only to those with clean mouths.

A dervish who lived in the country, far from the town in which his sheikh resided, had a dream. He felt it was an important dream, one that he should tell his sheikh right away. He dreamed that his body swelled up, as if he were pregnant. Then a large snake came out from his belly and his body returned to normal size.

As he was too busy to visit his sheikh, the dervish called in his most trusted servant. He told the man the dream and instructed him to go to town and tell the dream to the sheikh. The servant was not to tell the dream to anyone else, or even to think about the dream himself. The dervish knew that it was important for dreams to be revealed only to the dream interpreter.

The servant immediately set out for town. On the road he met an acquaintance, a well-known busybody. The man asked the servant what he was doing and the servant replied he was traveling to town. "Why? What are you going to do there?" asked

the man. The servant replied, "I have an errand to run for my master." "What is it?" "It is personal and confidential."

The man kept pressing the servant for more details until the servant finally told him that he was going to his master's Sufi sheikh to tell him a dream the master had the night before. The busybody then began asking what the dream was about. The servant refused to tell him, but eventually the busybody wore down his resistance. "My master dreamed that he became all bloated," began the servant. The man didn't wait for him to finish, but laughed and said, "And then he popped, just like a balloon pricked with a pin!" His curiosity satisfied, the busybody went off.

The servant hurried to town and came to the house of the sheikh. When he was admitted into the sheikh's presence, he began, "My master had a dream last night that he asked me to ask you to interpret. He dreamed that his body had swollen up . . ." At that moment the sheikh said, "Stop! The dream has already been interpreted. There is nothing more I can do. Return home and inquire after your master."

The servant returned home to find that his master had died. A few hours after the servant left, his body began to swell up and then, suddenly, he died.

This story is admittedly an extreme case. It is often used to bring home to new dervishes the importance of bringing their dreams to their sheikh. Then, after the dream has been inter-preted, it can be told to others.

* * *

One important aspect of the question of dreams is intention. That is, what questions you put to your dreams. A form of meditation or contemplation is necessary in order to "incubate" or to ask for a dream.

It is reported by the Companions of the Prophet (God's Peace and Blessings upon him) that he instructed them to remember their dreams and to bring their dreams to him and have him

interpret them. In addition, he taught them how to incubate dreams in order to obtain teachings through them.

A true incident from Ottoman history relates to the subject of dream interpretation. In fact it also relates to our particular Sufi order, the Halveti Order. At that time, the Sheikh of Islam was more or less equivalent to the Pope. The Sultan was the absolute secular ruler; however, his powers were limited by Islamic Law, which covered all areas of life. One of the major jobs of the Sheikh of Islam was to interpret the religious law. His religious edicts had all the force of law.

The Sheikh of Islam lost the key to his safe, where he kept his most important documents and his most valuable treasures. He tried everything he could think of to find the key. Finally, he asked for a dream to tell him where the key was. It worked. He dreamed that he went into an orange orchard, picked an orange from a tree, cut it open and found the key there. But how did that help him find the key? How to interpret the dream?

The Sheikh of Islam inquired throughout Istanbul, which was then the capital of the Ottoman Empire, to find the finest inter-preter of dreams. He sought help just as the Pharaoh sought out Joseph (God's Peace upon him) as a dream interpreter.

His advisors recommended a Halveti sheikh, Abdul-Rahman Efendi. He was invited to visit the Sheikh of Islam, who told him the dream. The Sheikh of Islam said, "I asked for a dream that would reveal the location of my lost key. This dream was given to me, but what does it mean?"

Abdul-Rahman smiled and told the Sheikh of Islam to send his butler to the library of his palace, and to bring them the thickest, biggest book in the library. The butler went to the library and brought back a huge volume, a concordance to the Holy Qur'an. Abdul-Rahman said, "In the name of God, the Merciful, the Compassionate." Then he picked up a letter opener and stuck it in between the pages of the book. He opened the book and there was the key!

The Sheikh of Islam told Abdul-Rahman that he had studied the interpretation of dreams and had read many books on the

subject, but he couldn't figure out this kind of dream. Abdul-Rahman answered that "God gave the gift of dream interpretation to Jacob and to his son Joseph. To a much lesser degree, my interpretation of your dream is a kind of minor revelation, or minor miracle."

I firmly believe that. I have read many books on the interpretation of dreams—and there are many available. These books claim that a horse means that, and an apple means this, and a fish means that. These are not real interpretations. This approach does not work. It is hit and miss. But it is possible to interpret dreams correctly. True interpretation is almost inherited, a gift of God, as was given to Jacob and to Joseph, and also to our Halveti-Jerrahi Order.

An example of interpreting symbols according to the situation of the dreamer also involves Sheikh Abdul-Rahman. Two people came to him one day. The first man said that he dreamed that he climbed up a minaret and chanted the call to prayer. The sheikh immediately told him, "You had better start making preparations for travel to Mecca. This year you are going to make the pilgrimage." As soon as he left, the second man came and reported the exact same dream, that he dreamed that he climbed up a minaret and chanted the call to prayer. The sheikh said, "You had better return what you have stolen, because otherwise you are going to be caught and it will be very bad for you!" Open-mouthed, the man admitted that the interpretation was correct, and promised never to steal again.

New dervishes may dream strange or even nightmarish dreams. They dream of snakes and scorpions and similar things.

These dreams are not really interpreted. All the sheikh does is give the novices medicine, so to speak, for their condition. Certain duties are assigned, such as repetition of certain names of God or certain prayers. Strange dreams simply show how the novice's ego is sliding right and left, doing whatever it can to avoid being transformed by the Sufi path. The novices have to be given help and protection, led to the right inner path, and so they are given various spiritual tasks and duties.

When a new dervish dreams about a snake, it is likely to be a sign of the lowest self, desires and egotistical impulses which dominate his whole being. In other cases, the snake might represent tyranny, or something else entirely.

For example, some years ago, a man I had never met came up to me, frightened and trembling. (I used to be the preacher in the great Suleiman Mosque in Istanbul. This man had heard me preach and recognized me.) First, I ordered coffee and tea for us. I knew he was going to ask me something important.

The man said that he dreamed a terrible dream, in which a big hole appeared in his belly and a huge snake came out. I smiled and said, "You have an important business matter with the government. You have hopes of inheriting something and you have made application to the government to obtain your inheritance. It will come out well for you. In fact, you will be so successful that all your friends will envy you."

The man was in shock. He put his hand in his briefcase and pulled out a sheaf of papers. He said that he had inherited large land holdings in a distant city and there was some opposition to his ownership. He had applied to the government and was not sure how it was going to turn out.

Dream interpretation is a direct message which one receives as the dream is told.

I am not trying to make you think that I perform miracles. I just mentioned this story as an example of what I have been telling you.

* * *

It is quite difficult to think in the symbolic terms we find in dreams and revelations. For instance, why did the staff of Moses (God's Peace upon him) turn into a snake? Why didn't it become some other kind of animal—a dog, a wolf, or a lion or tiger? Why did the staff turn into a snake when Moses threw it on the ground?

The inner quality of Moses is like a mirror. This was also true of his staff or whatever he touched. When the Pharaoh looked at the

staff, he saw a symbol of his own lower self, his inflated, horrible ego.

Did the staff really become a snake? Yes, it did. But then, what is reality? Your experience of reality depends on your inner state.

In the Hereafter it is the same. There is really no fire in hell, nor are there treasures in heaven. Everything is brought from here. What you do in this world goes with you. Your deeds will become either the bricks of your palace in heaven or your firewood in hell. Don't think that everything is finished when you die.

You are really asleep here. What you see here is a dream. It is at death that you will wake up and see reality.

* * *

Let me tell you a story which pertains to this question of dreams and reality. This story is about Said Pasha, who was the prime minister of the Ottoman Empire about ninety years ago. When Said Pasha was a child, his father, following an old custom, had him visit regularly a wise old man. In those days, this was an important part of a child's education.

In order to ensure that his son would visit the old man regularly, the father of Said Pasha would give his son's weekly allowance to the old man. Every week, the father would say to Said, "Well, it's time to get your allowance now. Go and visit your teacher."

This practice is like studying history. The older man does not even have to be a wise man, because he is an accumulation of mistakes as well as good deeds. For a child to learn of mistakes is in itself a great lesson. This traditional educational apprentice-ship was designed to learn about life, not to learn a profession. Those who fail to take lessons from history or from the lives of others become an example themselves in the mistakes they make.

The old man Said visited was a Sufi sheikh, not just an ordinary old man. Said received his allowance as usual, and while he was

there, a young gypsy came to the door. This gypsy came to the sheikh every few days. He usually talked about his life and would then "sell" some odds and ends to the generous old sheikh, who would always pay him some money instead of giving him charity.

This time the sheikh told the gypsy, "Enough! My house is filled with things you have brought to me. I don't want anything today." The gypsy said, "O sheikh, I'm not going to sell you anything today. I just want to tell you a dream which I have dreamed."

"In that case, please come in."

After hearing the dream, the sheikh said, "It is a fantastic dream. Although I am not going to buy any pencils or chewing gum or trinkets from you today, would you be willing to sell your dream? Would you sell your dream to the young man here for his entire week's allowance?" (The young man received a silver dollar a week from the sheikh, a lot of money in those days.) The young gypsy said, "Of course." He usually received a few cents each for the things he sold the sheikh.

The sheikh told Said to buy the dream, and Said reluctantly obeyed. Years later he admitted that he was really furious with the sheikh for taking all his allowance money and giving it to the gypsy.

When the sheikh took the silver dollar and handed it to the young gypsy, he said, "Now, have you sold your dream?"

"Yes."

"I am a witness to this, as are the other people here. We have all witnessed that you have sold the dream to little Said here." Then the young gypsy left.

Said was almost in tears because he lost his weekly allowance. The sheikh said, "Child, don't cry. You don't know what we bought."

Said replied, "Oh? What did we buy? Nothing!"

"O child, that gypsy beggar's dream would have made him prime minister, but I got it for you because you have a good character and you will make a better governor. You are going to

be the future prime minister. I congratulate you."

Said Pasha did become the Prime Minister, or Grand Vizier, of the Ottoman Empire, and a very great one too. He often told his friends and acquaintances that he had purchased his position for a silver dollar!

However, by a strange coincidence, the next prime minister after him was of gypsy origins. So, perhaps these things cannot be completely bought and sold. Even though the young gypsy sold his dream and missed becoming prime minister, somehow the post came to the gypsy people afterwards.

I hope that I have given you some sense of dreams and dream interpretation. Dreams are essentially information which comes from the divine knowledge contained in the mother of books, reflected on the screen which the soul reads at sleep. Dream interpretation is possible for those with wisdom and intuition, and for those who receive as a gift the ability to understand dreams.

SUBMISSION

FTER God saved the prophet Abraham (God's Peace upon him) from the furnace of Nimrod, in gratitude he sacrificed one thousand rams, three hundred oxen and one hundred camels. No one had ever heard of such a generous sacrifice before.

When asked why he sacrificed such great wealth, Abraham replied, "I was ready to sacrifice my very life for God. Why should I not sacrifice my goods? Besides, whose goods are they, really? The owner of my life and all that I possess is God. What I have given up is nothing. I would sacrifice my most valuable possessions for God's sake. If I had a son, I would even sacrifice him if God wished it."

How about us? Could any of us say the same? And even if you are not at the level of the prophet Abraham, how willing are you to sacrifice even some of the goods God has bestowed on you, to give of your goods in charity and in service to others? In fact, anyone who refuses to help others or who belittles the charity of others is not even a human being, much less a friend of God.

Some years later, God granted Abraham a son, Ishmail (God's Peace upon him). Ishmail showed the signs of prophethood at an early age. He traveled everywhere with his father and, even as a child, took part in the most complex religious debates.

Then God came to Abraham in a dream and said, "Fulfill your promise! You said that if you had a son, you would sacrifice him for my sake. Now you must fulfill your promise." (In the Qur'anic version of this Biblical story Abraham is told to sacrifice his first-born son, Ishmail, rather than Isaac.)

The next day, Abraham reflected on his dream. Although God had appeared to him in dreams before, he knew that God was opposed to human sacrifice, that no prophet had ever been asked to sacrifice another person. Instead, he sacrificed one hundred camels.

That night, again God came to Abraham in his dreams and told him once more to fulfill his promise. Again, the next day, Abraham reflected that God never wanted human sacrifice. Once again Abraham sacrificed one hundred camels.

The third night God came to Abraham once more and told him to sacrifice his only son. The following morning Abraham decided that he had to carry out God's wishes.

Abraham told Ishmail to accompany him to the place of sacrifice. On the way, Satan appeared to Abraham and questioned God's command. "Are you really going to cut the throat of your only son? Not even an animal could do a thing like that." Abraham replied, "Although what you say might seem reasonable and logical, I have received my commands from God and I am going to carry out His will!"

Satan fled from Abraham, but he did not give up. He went to Hagar, Ishmail's mother. Satan told Hagar that Abraham was about to sacrifice her son. Hagar replied that Abraham was a true prophet who knew God's will and carried out God's commandments. She said that she too was willing to sacrifice her own life, if God so commanded. Then she told the Devil to go and to leave her alone.

Finally, Satan tried to influence Ishmail. He appeared to the child and told him his father was going to tie him to the altar and cut his throat.

Satan said that Abraham had imagined that God commanded him to do so. The boy replied that his father was a true prophet, who knew God's commands, who did not "imagine" such things. Ishmail said he was fully prepared to offer his own life if God so commanded.

Satan asked Ishmail once again if he was willing to let his father cut his throat. Furious, Ishmail cried, "If God has truly

ordered my father to do this, I'm sure he has the strength to carry out God's command. And I shall, as well!" Then he picked up a stone and threw it at Satan, blinding him in one eye.

The Devil tries to tempt us in exactly the same ways. He tries to appeal to our reason, arguing that God does not really want us to carry out difficult or onerous duties. He tries to appeal to our compassion, our softer side, arguing that certain duties are too painful or place too great a hardship on ourselves or others. He tries to confuse us, to breed doubt, to make us afraid to follow God's will.

During the Hajj, the Pilgrimage to Mecca, all pilgrims go to Mina and throw stones at three pillars there. It was in Mina that Abraham went to sacrifice Ishmail. The three pillars represent the three rejections of Satan, by Abraham, Hagar and Ishmail. At each pillar seven stones are thrown, representing the pilgrim's rejection of seven negative qualities. These are: self-righteousness, arrogance, hypocrisy, envy, anger, love of status, and greed.

When they arrived at the place of sacrifice, Abraham told Ishmail of his dreams. Rather than lead his son to the altar in ignorance, Abraham asked Ishmail if he was willing to fulfill God's wishes and offer himself as a sacrifice. In submitting to his father, Ishmail teaches all of us the ideal of being willing to sacrifice even our own lives for the love of God and in obedience to our parents.

Although we should be willing to do anything in obedience to our parents for the sake of God, if parents order us to do something displeasing to God we should not obey. While remaining polite and respectful, we should refuse to obey anyone if they ask us to disobey God's wishes.

Ishmail agreed to the sacrifice. He told Abraham to bind him tightly with a rope, so that in his death throes he would not injure his father. He also asked his father to lay him face down on the altar so Abraham would not have to see his son's face, which might cause his hand to tremble and be unable to cut. Ishmail also asked Abraham to tuck up his robe so that he wouldn't come

home with his son's blood on his robe, causing more grief to his wife.

Abraham agreed, deeply touched by his son's faith and compassion. He laid Ishmail on the altar and then prayed to God to have mercy on him and his son. As he raised the sacrificial knife God said to the angels, "Look at the faith and love of my friend, Abraham. He is even willing to sacrifice his only son in obedience to my commands."

Then Abraham attempted to cut his son's throat with the razor-sharp sacrificial knife. Nothing happened. There was not even a scratch on Ishmail. Abraham tried again with the same result. He tried a third time but still the knife would not cut. Then, Abraham struck a nearby rock with the knife. The blade split the rock in two.

God gave speech to the knife blade. "You see, Abraham, only God's Will enables knives to cut, fire to burn and water to drown. Unless God permits, I can cut nothing. And if God wills, I can even split stone."

Then the angel Gabriel appeared before Abraham and revealed that God wished Abraham to sacrifice a ram instead of Ishmail, and that God was pleased with them both.

God demands sacrifices of all those who would know their Lord. We are asked to sacrifice for God's sake what we often love best—our attachments to the world, our bad habits, our arrogance. The great lovers of God have often found that once they have been willing to give up anything other than God, they received everything—material as well as spiritual abundance.

PATIENCE

IN a small Turkish village, a man named Hussain married his neighbor's daughter. At the wedding reception, Hussain was fascinated by the conversation of the two religious scholars who had been invited to come and perform the wedding. The men quoted from memory long passages from the Qur'an; they traded complex interpretations of religious law and discussed the various meanings of Arabic phrases. Hussain asked the men how they developed such knowledge and sophistication. They told him that they had spent many years studying at the great religious academies in Istanbul.

The next morning, after his wedding night, Hussain said to his new bride, "I am twenty years old and I honestly feel I know nothing of real importance. I wish to go to Istanbul and become a scholar. Please take care of our farm and of my parents while I am gone. I will return as soon as I become a scholar."

Hussain went to Istanbul, which was many weeks' journey away. He spent the next thirty years studying, going from one teacher to another seeking knowledge. At fifty, Hussain finally left for his home town, dressed in the robes of a scholar of the highest rank.

On the way home he stopped at a small village approximately a day's journey from his home. It was evening, and he went to the local mosque to pray. The villagers were thrilled to find a religious scholar in their midst, and they asked him to give a short sermon after the prayers. Everyone was delighted to hear his wise words, even if they did not understand most of his erudite comments. Afterwards, several of the villagers came up and

invited Hussain to stay with them that evening. The first man who offered insisted that it was his right and Hussain agreed to stay with him.

After dinner, the villager asked Hussain how he came to be a scholar. Hussain recounted the story of his life, how he left his home the day after his wedding in order to go to Istanbul to become a scholar. He recalled that he left at twenty and now was returning at the age of fifty. Tears came to his eyes as he thought about the family and friends he had left for so long.

The villager asked, "May I ask you a question?" Hussain said, "Of course, ask whatever you wish." Then the villager asked, "What is the beginning of wisdom?" Hussain replied, "The beginning of wisdom is to ask for God's help in all things."

"No, that is not the beginning of wisdom," said the villager.

Hussain said, "Then, to say 'In the name of God, the Merciful and Compassionate' before each activity is the beginning of wisdom."

"No, that is not it either," replied the villager.

Hussain went through all the scholarly answers he had learned over the last thirty years, but the villager refused to accept any of them as an adequate answer. Finally, Hussain gave up and asked the villager if *he* knew. The man admitted that he did. Hussain asked his host to teach him the beginning of wisdom.

The villager said, "I cannot teach you in one evening what you have not been able to learn in all your thirty years of study. You are a sincere and intelligent man. I'm sure I can teach you the beginning of wisdom in one year. There are those who can never learn this, no matter how long they try." Hussain agreed to stay with the man for one year in order to learn the beginning of wisdom.

The next day, the villager took Hussain with him to the fields. They worked so hard that Hussain returned to his home that evening exhausted. This continued for an entire year. Hussain had never worked so hard in his life. He did it all with the goal of learning the beginning of wisdom, but whenever he asked his host, the villager always told him to wait.

Finally, the year was up. When they returned home, Hussain asked the villager finally to teach him the beginning of wisdom. The villager replied that he would teach it to Hussain the next morning. Hussain burst out, "Is it that short?" The villager replied, "It is short in the telling, but not in the understanding."

The next morning, after breakfast, the villager asked his wife to prepare a sack of food for their honored guest, including some fresh bread for his journey, some fruit and meat. "Forget the food," cried Hussain. "Tell me what is the beginning of wisdom."

"Have patience," said the villager, who continued to make preparations for Hussain's departure.

"Don't try to cheat me," cried Hussain. "I spent a year working like a donkey just to learn the beginning of wisdom. What is it?"

"Patience," said the villager.

"No, don't put me off again," cried Hussain. "You must tell me now!"

The villager turned to Hussain and said, with the utmost seriousness, "The beginning of wisdom is patience."

Hussain became furious. "You have made a fool of me and taken advantage of me. I can quote volumes on the subject of patience! I know every verse in the Qur'an that mentions patience!"

The villager answered him, "When I asked you what was the beginning of wisdom a year ago, you were not able to answer. And when I asked you if you were willing to spend a year with me to learn the answer, you agreed. You were not able to understand the answer a year ago. A whole year I have been teaching you about patience and how you must be patient to learn anything of importance. You have experienced patience, and that is the real learning.

"A scholar full of undigested wisdom, who has not learned to apply what he knows in his own life is just like a donkey carrying a load of great books. The books have done nothing for the donkey, and by your outburst, it appears that all your learning has done nothing for you.

"It does a terrible disservice to others to learn a great deal and

then to teach others if you haven't put your learning into prac-
tice. If people hear you quoting the words of the great prophets
and saints on faith and charity, and then observe that you your-
self lack these qualities, they will see that you are a liar. Even
worse, they may come to disbelieve those divine truths you talk
about. What do you think would be your reward if those you
were attempting to teach actually lost their faith because your
actions did not match your words?

"That is why your study of patience is so important. A real
scholar is one who applies what he knows to himself. Without
that, there is only falsehood. So, return home and share your
knowledge with your neighbors, but you must never forget to
apply in your own life what you have learned in your studies."

This was not your ordinary villager. He was a true teacher, a
saint who taught the deepest truths to those who were able to
learn from him. Through him, Hussain was able to begin to
assimilate his thirty years of study.

Hussain walked slowly back to his home town, thinking about
what he had heard that morning. It was dark by the time he
arrived at his old home. As he looked into the window of his
home, he saw his wife sitting with her arm around a young man,
caressing his hair. He was shocked, then infuriated that his wife
had taken up with someone else while he was away. Hussain
drew out the pistol he had bought in Istanbul to protect himself
from robbers on the long journey home. As he was just about to
shoot the pair, he remembered his year-long lesson in patience.
To take human life was not a small thing.

Hussain resolved to find out all the facts before acting. He
went to the village mosque where people were beginning to
gather before evening prayer. The villagers were all impressed
by Hussain's scholar's robes and treated him with great respect.
No one recognized him and Hussain began to ask questions
about his old friends and neighbors. Many of those older than he
had died. His friends were virtually all grandparents.

Then he asked, "What about that man named Hussain who left
here to go to Istanbul years ago?" One of the men answered, "We

have heard nothing about him for over thirty years. His wife had a very hard time after he left, the day after he married her. She had become pregnant that night and worked hard all these years raising their son all by herself. Not knowing what had happened to her husband, whether he would return or not, she brought up her son to be a scholar just as her husband had wanted to be. He is now our teacher and our imam. He should be along shortly to lead the night prayers."

Hussain was deeply moved by this recital. He began weeping as he thought of the struggles of his wife and of the son he had never even known of until that moment. Just then a handsome, radiant young man dressed in an imam's robes entered. It was the same man Hussain had seen in his home.

After the prayers were over, Hussain turned toward the village of his teacher and bowed deeply, crying out, "A thousand thanks and a thousand blessings on you, my peerless teacher." When the villagers asked him the meaning of his strange actions, he told them the whole story, that he was that Hussain who had left the village thirty-one years ago seeking knowledge, and how he had spent a year learning patience, which had prevented a terrible tragedy. He embraced his son and the two of them returned home together.

TEMPTATION

URING Ramadan, the month of fasting from dawn to sunset each day, the great sheikh Abdul-Qadiri Gaylani (May his soul be sanctified) was crossing the desert with his dervishes. They were exhausted from the heat and from hunger and thirst. The sheikh rested by the road as his dervishes pressed on. Suddenly a great light appeared before the dervishes, and words came from the light. "I am the Lord your God. You are all favored, faithful followers of My beloved sheikh. Today I have made food and drink lawful for you. Now you may eat and drink."

The dervishes began reaching for their food and water when Abdul-Qadiri Gaylani came up. He cried, "Stop! Do not break your fast." Then the saint said to the light, "I take refuge in God from the accursed Devil." The light immediately turned pitch black.

Once he was found out, Satan appeared. He said to the sheikh, "You know, I have been trying this trick for thousands of years and you are the first one who has seen through me. How did you do it?"

The sheikh replied, "I knew who you were from three kinds of knowledge. Those who have this knowledge and who practice it can always recognize Satan. They can distinguish lawful from unlawful, true from false.

"The first kind of knowledge is the science of jurisprudence, the laws given to us by God through the prophets. According to Islamic law we cannot break our Ramadan fast unless it is a question of life and death. No one here was actually dying of

thirst. So your order violated the law. Only the Devil would do that. God does not give us laws and then change them.

"The second is the science of theology. We know that God has no fixed location. God is the place of all places. The prophets have all said that when God speaks, the Divine voice comes from everywhere, from every direction. That voice came to us from a single direction, from the light. I knew it must be the Devil, not God.

"The third is the science of Sufism. All the great Sufi guides have taught that if God were to manifest to us, our inner state would change radically, our lower nature would be obliterated. But no one experienced any change of inner state. Had God truly spoken to us, our strength, even our consciousness would have vanished."

The Devil exclaimed, "Oh, you are truly the teacher of the age. Let me bow before you, a great saint of such wisdom and holiness. You really should have many more dervishes. You must be very pleased with yourself for having outwitted me so completely."

At this, the sheikh drew himself up and cried once more, "I take refuge in God from the accursed Devil!" The Devil disappeared, having failed to play on the sheikh's pride.

You see how the Devil never stops trying. He can often catch us through our pride when every other trick has failed. The Devil is the implacable foe of humanity, and will go to incredible lengths to lead us astray. He sometimes misleads people by pretending to be a spiritual guide, or even to be God Most High. Safety lies in study and practice of religious law and spiritual teachings.

For someone who only knows the religious law, that knowledge is like a garden fence. The garden may not only contain flowers and fruit trees. There may also be weeds and thorns. The fence will keep out harmful beasts; however, if some animals do get in, the same fence may keep them there.

Spiritual knowledge can serve as a barrier against evil, but it will not completely protect your heart from greed, anger, and

misconduct. Bad influences cannot easily penetrate, but they may remain once inside.

Spiritual practice without knowledge is like a wide open garden. It may yield fruit and flowers, but nothing will stop the animals from devouring the fruit and trampling the flowers. Unless they are surrounded by a wall of knowledge, devotion and inspiration are easily lost, or can even turn into hypocrisy, spiritual pride or arrogance.

In a sense the religious law and the mystical Sufi path are like a pair of wings. One alone can accomplish nothing. You need both. You must cleanse yourself of outward material impurities and also purify your inner being of impurities like pride, hypocrisy, dishonesty, anger, greed and love of fame and status.

Sufism without Islam is like a candle burning in the open without a lantern. There are winds which may blow that candle out. But if you have a lantern with glass protecting the flame, the candle will continue to burn safely.

It is very important to remember that the religious law and the Sufi path are both good. Just because you cannot do both, it is not wise to abandon the one which you are doing. And if God wills, for those who want to cleanse the inside of the house, the outside walls one day will be built as well.

God Most High does not look at His creatures outside, at their external beauty. God looks into their hearts, into the cleanliness and beauty inside their hearts.

On a higher level, you must understand that cleansing the outside is much easier than cleansing the interior. Do not fool yourself by thinking of cleansing your heart without cleansing your outside. For example, if you think of money—a symbol of this world—as dirty, you can always wash your hands after handling it. But if your heart is captured by desire for money, it is very hard to cleanse that.

On that level, trying to cleanse your inner nature first is much, much harder than starting from the other side. But if you are able to do it, the exterior will shine like crystal. If you are able to do it.

You can spend a couple of dollars and go to a barber, take a

shower, and go to a shop and buy yourself beautiful clothes. Externally you can easily make yourself attractive. But what effort and what wealth it takes to cleanse yourself within!

The ideal is to have your exterior and interior in harmony. Your outside should be like your inside. What is extremely important is completion and unity.

This example is a little vulgar, but someone who is clean outside but dirty inside is like a toilet. We keep the outside clean but the inside is obviously dirty. And in the old days in Turkey, before there was running water, they kept a pitcher in the bathroom filled with clean water to wash yourself after using the toilet. The inside was clean, but the outside of the pitcher sitting in the bathroom was dirty. Neither one is good—clean inside but dirty outside, or clean outside but dirty inside. We must become like a crystal bottle, clean and transparent both inside and out.

A saint of our order exemplified this. Niazi Misri (May his soul be sanctified) is a very important saint because many secrets, impossible for ordinary people to understand, became comprehensible through his poetry, by the grace of God. But every saint on this path will have to walk on thorns. Niazi was exiled to the Greek island of Lemnos. The Sultan wrote him very politely, "God and you know why I have to go through this and exile you." It was a very courteous thorn.

Niazi was sent to Lemnos with shackles on his arms and legs. He could not keep his body and his clothes clean while shackled in the dungeon. Eventually he died. Actually he did not die, he "became." Only animals die; real human beings become.

According to Islamic law, the body is washed before burial. An orthodox Islamic washer of the dead was washing the body, and said, "Eh, look at you. They call you a saint but how could you be so dirty at your death!" And the dead saint sat up and said, "We haven't found the time to cleanse our outside while we were cleansing our inside." The washer passed out.

You see, saints don't die. They become.

* * *

It is very important to understand that the outer religious law makes your coarse being, your exterior, high in the eyes of God and humanity. But God also sees your inside; even if your exterior is sloppy, God sees what is inside. On the other hand, the believer is the mirror of the believer. Thanks to your exterior cleanliness, you will be accepted in good company. However, if your inside is dirty, that will be revealed eventually, and you will be expelled from that good company. A clean exterior provides an entrance. It is a passport for you to enter into the society of good people.

There are different levels of people, as you well know. Each level has a color, except for the highest level which is transparent. This is the level of the friends, the lovers of God. At this level your exterior is irrelevant because, having become transparent, everyone can see who and what you are. Your inside and outside have become unified, precisely like a fine crystal bottle filled with pure spring water.

On the other hand, there are some Sufis who deliberately make their exteriors ugly. This is not really by choice, however, but by God's will. It is given to such people by God to attract the anger and scorn of others. This requires great inner strength, and also the help and protection of God. A real saint can afford to appear as a Godless drunkard.

All these things need to be considered in answering this question of balancing inner and outer growth. There is no straightforward yes or no answer!

* * *

The disciples of Abu al-Bistami once complained to him about the Devil. They said, "The Devil takes away our faith." The sheikh then summoned the Devil and questioned him. The Devil said, "I cannot force anyone to do anything. I fear God too much to dare to try that. Actually, most people throw their faith away for all sorts of trivial reasons. I simply pick up the faith they throw away."

The Devil has every human quality, except for one thing. The

Devil does not know love. Love was not given to the Devil. Love is the legacy of Adam.

* * *

A pious woodcutter once lived in the woods with his family. Nearby lived a tribe of pagans who worshiped a pine tree. The pine tree was their idol; they prayed to it.

One day the woodcutter said, "I am going to go cut down that pine tree. I am sure that God will reward me for that deed, which will prevent them from being pagans and praying to an idol. At the same time, I will get a nice pine tree to sell in the market-place. That will kill two birds with one stone."

As he was walking, axe in hand, toward the tribe, a man came up to him and asked, "Where are you going?" The woodcutter said, "I am going to the tribe that worships a pine tree and cut down that tree." The man said, "No, no. Don't do that."

"Who are you to tell me not to do that? I am going to do it for God's sake. I am going to chop that pine tree down."

The man said, "Well, I told you not to do that."

"Who is going to prevent me?"

"I am."

"Who are you to prevent me from cutting that pine tree down?"

The man replied, "I am Satan. I am the Devil. You can't cut the tree down. I am going to stop you."

The woodcutter cried, "You! You cannot stop me." And he grabbed the Devil and threw him down on the ground. He sat on the Devil's chest and put his axe to the Devil's throat, ready to kill Satan.

The Devil said, "You cannot kill me. God Most High has given me life until the Day of Last Judgment. And my duties until that day are to lead everybody astray." The Devil went on, "Look, how much money do you make? I know that you are a devout man and you have a big family, and also that you like to help people."

"I make two copper pieces a day."

"You are very unreasonable. You are going to try and chop

down that pine tree but the tribe will not let you cut down their god. They may kill you and then your family will be left destitute. Be reasonable. Leave that project. And I'll bargain with you. You say you make two coppers. Every morning, I will put under your bed two fresh gold coins. Is that a deal? You are a devout man. Instead of going and getting yourself killed, which you may easily do, you will get two gold coins, and spend it on your family's needs. And what is left you can spend on the poor."

The man replied, "I don't believe you. You are going to cheat me. Everybody knows the Devil is a cheat and a liar. You just want to save yourself."

The Devil said, "No, no. I'm not going to cheat you. Besides, try me. Go home and don't do anything. If you don't find the two gold coins you can always take your axe and chop the tree if you want to."

"That sounds reasonable." The man went home. The next morning the man looked under his mattress and found two brand new gold coins. He went to his wife and said, "Wife, we have things all fixed up for the rest of our lives. I made a contract with the Devil. I don't even have to work. Every morning we will get two gold coins that we can spend as we wish." The woman was not so sure. She said, "Don't you know the Devil is a liar?"

"But here are the two gold coins!"

They ate well. There was a little bit left, which they distributed to the neighbors on the right and on the left. The next morning, bright and early he got up and put his hand under the mattress. Nothing. He lifted the mattress. Nothing. Pillows, carpets, he even lifted the floor up, but found nothing. "Ah, he cheated me." Angrily, the woodcutter took his axe and set off to chop down the pine tree, the idol. On the road he found the Devil again, this time smiling. The Devil said, "Where do you think you are going?"

"You cheat, you liar! I'm going to go and chop that pine tree!"

The Devil tapped the woodcutter on the chest with his finger and the man was knocked over. Satan said, "Look, do you want

me to kill you now? Yesterday you wanted to kill me."

"Oh, no, no, don't kill me, and I don't want any money from you either. I just want to ask one thing. Just two days ago, when you wanted to stop me from cutting down this idol, I defeated you very easily. I just grabbed you and threw you down, and I was just about to kill you. Where did you get this force today?"

"Ah, the day before, you were going to cut that tree for God's sake. Today, you were fighting me for the sake of two gold coins."

* * *

A merciless bandit once had killed ninety-nine victims. He went to an orthodox religious teacher and said that he wanted to change his life, to repent for his misdeeds. The teacher told the bandit that he could never be pardoned for all the murders he had committed. Enraged, the bandit said that as long as he was not going to be pardoned, he would take the teacher's life as well. And so he cut off the man's head.

Soon after, the bandit came upon a wise man, a scholar who truly digested and practiced what he taught. He asked the wise man if he could ever be pardoned for killing one hundred innocents. The scholar replied that God does pardon sincere repentance. He added that the bandit should leave his home town, which was filled with robbers and other wicked people. He should move to the nearest town, which was the home of many honest and righteous people. Good company leads us to good behavior and bad company leads us to sin.

The bandit returned home, packed his things and set out for the city of the righteous. A few steps from his home town, the bandit's hour of death arrived. As his body fell to the ground, the guardian angels came from Hell to take his soul. At the same time, angels from Heaven arrived and claimed him. The first group of angels argued that the bandit had murdered one hundred people and his soul had to go to Hell. The heavenly angels countered that the man had sincerely repented and that he had also put his repentance into action by leaving his home

for the town of the righteous.

Finally, the archangel Gabriel was sent to judge the matter. Gabriel asked God how to proceed, as there were strong arguments on both sides. God gave Gabriel a divine measuring rod and told him to decide by measuring the distance from the bandit's body to the two towns. If he died closer to the good people, his soul would go to Heaven; if he was closer to the bad people, his soul would go to Hell.

The angels all agreed to abide by God's procedures, although the Heavenly angels were sorry to lose his soul, as he had died a few paces from the city of evildoers. Gabriel then laid down the divine measuring rod and measured two feet from the bandit's body to the gates of his home town. As he turned the rod to measure the distance to the town of the righteous, instantly, by Divine Grace, those distant walls came right up to the body, less than a foot away. The repentant sinner's soul was given into the care of the angels of Heaven.

It is the same with us. If you truly wish to change your bad habits, change the company you keep. Most important, pray to God to have you stop. Don't take credit for improving. Your repentance is a blessing from God. So is your ability to act on your feelings of repentance. And, if you want to be a good person, seek out good people. If you want to love God, stay with those who love God.

* * *

One of the greatest sources of evil in the world is gossip and slander. But, you see, the Devil can be a great teacher. All you need to do is to find out what he wants, and then do just the opposite. For example, if you see another's wrongs, yet hide what you have seen from others, God will cover up and pardon seventy of your misdeeds.

God once asked Gabriel, "Oh Gabriel, if I had created you as a human being, how would you have worshiped Me?"

"My Lord, You know everything—whatever was or will be or might be. Nothing in heaven or on earth is hidden from You. You

also know how I would worship You." God said, "Yes, Gabriel, I do indeed know, but My servants do not. Speak, so that others may listen, and learn!"

Then Gabriel said, "My Lord, if I were human I would worship You in three ways. First, I would give water to the thirsty. Second, I would cover up the wrongs of others instead of speaking of them. Third, I would help the poor." God then said, "Because I knew you would have done these things, I had you convey My revelation, and sent you to My Prophets."

Cover up the sins of others, so your own sins may be hidden. Pardon others, so you may be pardoned! Do not throw others' misdeeds in their faces, or the same may happen to you.

You may know of one of someone else's misdeeds; God knows about a thousand of your sins. Suppose God exposes a fault of yours? Who will cover up your misdeed once God has revealed it?

Satisfy whoever asks you for help. If you refuse to help others, the world may later take from you what you would not give willingly. Remember, the station of Gabriel consists of providing water for the thirsty, hiding others' faults, and aiding the poor. Help those in need now. If you let your chances slip away today, a time may come when your opportunities to help others are gone forever.

Slander is a terrible habit. God hates slander. He says, "Believers, would you eat your dead brother's flesh? To slander your brother believer is to do exactly that, for he is not present to defend himself." The Prophet (God's Peace and Blessings upon him) has said that slander is even worse than adultery. Giving up slander and gossip is a great achievement, and ensures your success and salvation.

Bayazid al-Bistami (May his soul be sanctified) once said, "While attending a funeral, I saw a handsome, devout-appearing person who was holding a beggar's bowl. I was very surprised. I felt that such a fine-looking person should not be begging.

"I had a dream that night. That person's corpse was in front of me and I was told to eat his flesh. 'I cannot eat human flesh!' I

said. Then I was told, 'But you did eat his flesh today.' Actually, I had not even spoken to the man or criticized his begging to anyone else. I had the thought that to beg was not worthy of such a fine, devout person."

Just to think slanderous thoughts is considered a sin on the part of God's saints. The rest of us sin if we speak or act on our thoughts. The virtues of the pious are the sins of the holy.

* * *

There is great wisdom in acting for God's sake and refusing to act for any other reason. Once Ali (May God be pleased with him) was fighting on the battlefield with one of the most powerful champions of the enemy. He finally managed to strike the warrior's sword from his hand and knock the man to the ground. As he raised his sword to take the enemy's life, the man looked up and spat in Ali's face. The Muslim warrior stopped and sheathed his sword. The fallen man said, "I don't understand. You were about to kill me and yet after I spit at you, you spare my life. Why?"

Ali replied, "Before, I was going to take your life in battling for God's sake. When you spat at me, it enraged me. Had I killed you then, I would have been a murderer, for I would have struck in anger, for personal reasons. I will fight for God, but I will not murder for my ego."

The fallen warrior was so deeply impressed he became a Muslim.

* * *

A yezidi (Devil worshiper) came into my bookshop in Istanbul one day. I wasn't there, and the man asked my assistant for a book on Devil worship. My assistant said, "What did you say? That is the most horrible way of unbelievers." The two started fighting. At that moment, I entered. I calmed the yezidi by discussing the history and beliefs of the yezidis. I went on and on, and the man asked, "Are you a yezidi?"

"No," I answered, "but I am interested. I know about it."

The man was very happy and proud that a respected spiritual teacher knew about them and could talk about them.

It may shock you that there really are Devil worshipers like this man. But you don't realize there are so many among us who are totally under the influence of the Devil. God Most High warns us, "Didn't I tell you not to worship the Devil? He is clearly your enemy." If no one was a follower of the Devil, to whom was God talking? Obviously, there are a lot of us who knowingly or unknowingly worship the Devil.

But the Devil is useful. In our tasting this worldly life, the Devil is like salt and spices. Completely spiceless food has no taste. Without the Devil, life would be very bland. If not for the Devil, you would not have ambition, you wouldn't fight for this or that reward. There would be no police, no prisons, no lawyers, no judges. All these professions depend on the existence of the Devil. All these disruptions actually teach us order. We learn by experiencing the opposites.

One of the beautiful attributes of God is *Ya Muzill,* The One Who Leads You Astray. God guides whom He wishes and also leads astray whom He wishes. The prophets of God are manifestations of the attribute *Ya Hadi,* The Guide. One manifestation of the opposite attribute, *Ya Muzill,* is the Devil.

* * *

One day, the Devil said, "What is this? How unjust it is. Whatever people do, whatever bad happens, they always put the blame on me. What blame do I have? I am innocent! Look, I'll show you how they lay the blame for everything on me."

There was a powerful ram attached to a rope which was tied to a stake. The Devil loosened the stake and said, "There, that is all I'm going to do."

The ram tossed his head and pulled out the stake. The door to his owner's house was open, and in the front hallway was a big, beautiful antique mirror. The ram saw his reflection in the mirror

and he put his head down and charged. He shattered the mirror.

The mistress of the house ran downstairs and saw her beautiful mirror shattered. This mirror had been in her family for years. She cried to the servants, "Cut off that ram's head. Kill him!" So the servants killed the ram.

The ram was a special pet of her husband, who had fed the ram by hand when the ram was little. He came home and found his beloved ram dead. "Who killed my ram? Who would dare to do such a terrible thing?"

His wife cried, "I killed your ram. I had it done because he destroyed this beautiful mirror which was left to me from my parents."

The enraged husband said, "In that case, I divorce you."

Neighborhood gossips told the woman's brothers that her husband divorced their sister because she had a ram killed.

The brothers became extremely angry. They gathered together their relatives and went after the husband, armed with guns and swords. The husband heard they were coming and called his own relatives to defend him. The two families began a feud in which many houses were burned and people were killed.

The Devil said, "You see. What did I do? I just shook the stake. Why should I be responsible for all the awful things they did to each other? I just loosened the stake a little bit."

Watch your stakes.

* * *

The truth is that human beings can outdo the Devil any day. There was an extremely devout young man, who never missed a prayer. Of course, the Devil hates people like that. He tried and tried to lead the young man astray, but nothing worked.

An old woman was known to have her own personal Devil in her. That woman obviously knew the big chief. One day she said to the Devil, "I know that you are trying to lead that young man astray, and I see that you cannot succeed. If you wish, I can do that for you for a little reward."

"What do you want?" The Devil was ready to give anything.

"Look, I want a pair of red shoes. If you give me a pair of red shoes, I will lead that young man astray."

"Okay, it's a deal."

The next night the devout young man passed in front of the door of the old woman's house, on his way to prayer. The old woman came out crying, "Oh, oh, my chickens are all gone. They are all over the street. You look like a very nice young man who would like to do a good deed for an old woman. Would you kindly help me gather up my chickens?"

The young man agreed, and helped her gather the chickens and shooed them inside the courtyard. Once he was done, she said, "Ah, you are such a wonderful young man. Light shines from your face! You must be so devout, so beloved of God that I will ask you one more favor. My daughter is upstairs and she is terribly sick. I am sure that if you would go up and pray for her she will get better. Will you please do that too?"

The young man agreed and went upstairs. As soon as he entered the daughter's room, the old woman closed the door on him and locked it from the outside. In the room a very beautiful woman was sleeping in the bed. The old woman spoke through the door. "Look, young man. You must do one of three things. There is a big bottle of wine in the room, and the woman's baby is also sleeping in the room. You must either drink the wine, or kill the child, or commit adultery with the woman."

The young man was horrified, but he knew that he was caught. "I can't do that! I am a devout man. I have never sinned in my life."

"In that case, I am going to scream. The neighbors will come and I'm going to tell them that you have forced your way into my house and that you are about to rape my daughter."

He said, "Don't, don't do that." The young man looked around. Murder, adultery and drinking. The least sin is drinking, so he drank the bottle of wine. When he finished the wine, the woman looked very attractive to him. He grabbed her. As soon as he attacked her, the child began screaming. He lashed out at the child and killed the baby.

They caught the young man and hanged him as a drunkard who had committed murder and adultery.

Then the Devil came and tied the pair of shoes on a long stick. From far away, he stretched out the stick to the old woman and said, "Here are your shoes." Even the Devil did not want to get close to her!

One day, the Pharaoh was taking a bath. There was a knock on the door. The Devil came to visit him. The Pharaoh asked, "Who is it?" and the Devil replied, "You claim to be a god, and you don't even know who is behind the door?"

When he saw who was behind the door, the Pharaoh said, "I am not God, which both you and I know. And neither do you have the powers which you claim to have. It is just that God has given us this evil quality of tyrannizing people and gaining profit for ourselves. Now that we know who we really are, I wonder if there is anyone in the world worse than we are."

The Devil told him the story of the old woman and the devout young man.

Then the Devil went on. After she received those shoes from the Devil the old woman asked him for a favor, having done him such a good deed for only one pair of shoes. She said, "I have got a neighbor who is very devout. She has two cows, and every night these cows come in from the fields with their udders full of milk. She milks the cows and drinks the milk, and, even worse, she distributes the rest to the poor. What I want you to do is to lead those cows to the cliff and push them over."

The Devil said to the old woman, "Why? Doesn't that neighbor of yours give you any of the milk?"

"Yes, that is what bothers me the most. That is why I want those cows dead."

The Devil suggested, "Instead of killing those cows, let me give you two cows of your own. I'll steal two cows and give them to you. Then you can do whatever she does, if you wish."

She said, "No, no. I don't want two cows and I don't want her to have two cows."

The Devil said to the Pharaoh, "You see, this woman is worse than both you and I."

* * *

God said, "I have created Humanity as My supreme creation. I have created them better than any, including My angels." But this refers to those who beautify themselves with the qualities, the attributes of God which are given to them. Those are the human beings who follow the rules of the Qur'an and other holy books, and the examples of the prophets. But when people do not attempt to follow the guidance God has provided us through these scriptures and prophets, God also said, "I will make them lower than the lowest."

Sometimes such people look like human beings, but they are animals. They act worse than animals. Consider the most violent, carnivorous, harmful animals—the cobra, tiger, lion—after all, how much destruction can they cause? They can kill a few men and women. But a human being who becomes an animal can kill millions.

There is not just one Devil. The Devil and Adam were created at almost the same time. Actually, the Devil was created before; they descended to this world at the same time. When Adam was created, God asked all the angels to bow in front of him and the Devil refused. Because of that the Devil got kicked out of heaven. Then Adam came down to this world.

As we are all descendants of Adam, so too the Devil has descendants. One of the Devil's legs is male and one female. That is, the Devil is a hermaphrodite. The Devil procreates, so that each of us has our own personal devil.

The Devil appears in human form. It amuses him that everybody imagines the Devil ugly, with horns and a tail. The Devil is not ugly. The Devil is very beautiful. He appears to man in the shape of a beautiful woman. And, of course, he appears to women in the shape of handsome men. We all have our own devils, each of us, in our own shape.

Late one night the Prophet Muhammed (God's Peace and Blessings upon him) came out from the house of his young wife, Aisha. She was jealous and followed him out. He turned and

smiled and said, "Aisha, I see you brought your devil with you."

"I don't see anyone," said Aisha.

"Everyone has his or her own private devil."

Somewhat impertinently, she asked, "Even you, O Messenger of God, do you have your own devil?"

"Yes," he answered, "but I converted mine. I made him a Muslim."

* * *

When human beings remember God, angels are born. Gossip, criticism and other bad actions give birth to devils. These angels and devils born of our actions are like reflections of the real angels and devils. To give you a specific example, if you curse me, we will start fighting, killing each other, tearing each other apart. That is the creation of that devil. And in your devotions and in acting honestly and kindly, you are teaching others to act the same way, so good is being created. Those are the angels which are being created. These are not "material" angels or devils; they are like the reflections of angels and devils in a mirror.

The Devil has never been in paradise. The snake which was in paradise was a very beautiful being. It had four legs, which were taken away by God after what happened with Adam (God's Peace upon him). God ordered the snake to slide on its belly. But even now the snake is beautiful. Women make handbags and shoes from its skin. The snake was not the Devil. That incident had to take place. Adam had to eat of the fruit of the forbidden tree, and so God momentarily put the Devil on the tip of the snake's tongue.

There is a very important mystical meaning in that. The poison was the Devil, not the snake. Not even the tongue was the Devil, only the poison on the snake's tongue. That is a sign that what leads you astray is what is on your tongue, the poison of the Devil.

God says of the incident of Adam being taken from paradise, "Talking against each other, cursing each other; fall down, fall down from paradise and become enemies of each other." You

can see how this came true in just one generation. Cain and Abel became enemies because of poisonous speech. The source of all evil is people talking against each other and cursing each other.

I am often asked when can eternal peace be established in this world. From Adam onwards, you can see that every man and woman has had and will have an adversary. The Devil was against Adam, the Pharaoh against Moses, Judas against Jesus. That is our destiny.

The Devil was first an angel, actually an archangel. His name was Harris, which means the ambitious one. He was ambitious at prayer. He prayed to God everywhere in the universe. There is not a spot where he did not pray to God. But when God created Adam, the Devil thought that these prayers gave him special rights. He became arrogant. So when God asked him to prostrate in front of Adam, he refused. That arrogance, depending on his past prayers, caused the Devil to be cast out from the mercy of God.

When God told him to get out from heaven and go to hell, the Devil asked for time. He said, "I have prayed thousands of years for You, all over the universe." God agreed to give the Devil until the day of last judgment. The Devil then said that he would use that time to fool everybody and lead them astray. "I am going to be in front of them and behind them, and on their right and on their left."

God allowed this but said, "I am going to send all of those who follow you to hell. And I am going to manifest Myself from above and from below to everyone."

You see, the Devil claimed only four directions, leaving above and below to God. That is why we lift our hands up and bow our heads down in prayer.

* * *

One day, the Devil was strolling nude in the streets of Baghdad. Junaid Baghdadi (May his soul be sanctified) came across the Devil and said, "Look at you. Aren't you ashamed?"

"Ashamed of what?"

"Look at all these people around you, the whole city of Baghdad."

"You call them people. They are nothing to me. I can play with them like a man juggling balls. What does bother me is the two people in that mosque over there. I cannot even get close to them. If I got anywhere near that mosque their breath would burn me like fire."

Junaid Baghdadi was curious, so he went to the mosque. There were only two people sitting there, reciting *La illahe illallah*, "There is no God but God." Their faces were covered. One of them lifted the cloth in front of his face and smiled. He was a beautiful young man, very young, whose moustache was just beginning to grow. He turned and smiled at the great Sufi sheikh. "Oh, Junaid, do you believe whatever the Devil tells you?"

GENEROSITY

MANY years ago, a traveler came to a small town. The custom at those times was to open your door to whoever comes as "God's guests," as they were called. When someone knocked on your door and said "I am God's guest," you were to invite him in, feed him, and give him a place to sleep.

The traveler came upon a group of townspeople and asked, "Is there a kind person in town who has space to put me up for the night? The next morning I will continue my journey."

The townspeople said, "Well, yes, there is one person who does welcome guests. If you stay there, he will feed you, put you up, and be very kind to you. However, we have to warn you that he has a strange habit—in the morning, when you are leaving, he will beat you up."

It was winter and very cold. The traveler said, "I'm not going to spend the night on the street, hungry. I will go, and I'll take what comes to me. I will eat, sleep in a warm room, and if he'll beat me up, he'll beat me up."

The traveler knocked on the door and a very pleasant man opened the door. The traveler said, "I am God's guest." The man replied, "Oh, come in, please come in." He offered the traveler the best place, and his best cushions. The traveler replied, "Eyvallah." ("Eyvallah" means "As you wish." It literally means "As God wills." Eyvallah signifies our willingness to accept whatever we are given—good or bad, delightful or unappetizing—remembering that it comes from God.)

"May I put a pillow behind you to make you more comfortable?"

"Eyvallah."

"Are you hungry?"

"Eyvallah."

The host brought out a delicious dinner, and then asked his guest if he would like some more.

"Eyvallah."

The host said, "Coffee?"

"Eyvallah."

"Would you like a cigarette?"

"Eyvallah."

"May I make up your bed?"

"Eyvallah."

The host made up a wonderfully soft bed and put a feather comforter on it.

"Would you like some water before you go to sleep?"

"Eyvallah."

In the morning the host was up early. He asked the traveler, "Would you like some breakfast?"

"Eyvallah."

The host served a wonderful breakfast.

Once breakfast was finished the traveler realized it was time to take leave of his host. After the stories he had heard, he was afraid of what might happen, though this man had just devoted almost a day to take care of him. "I would like to take my leave now," he said, fearfully.

The host replied kindly, "Eyvallah," and added, "You seem to be a man without much money. Would you permit me to give you some money?"

"Eyvallah."

The host gave him ten pieces of gold. The traveler thought to himself, what a beating I'm going to get after this!

The host saw him to the door, saying, "May God go with you. Goodbye." The astonished traveler said, "I beg your pardon? There is terrible gossip going around about you. You are the

most generous person I have ever seen. They say that you act hospitably with guests but that in the morning you beat them up. May I go spread the word that you do no such thing, that you are a wonderful man and a wonderful host?"

The host said, "No, no. What they say is true."

The astonished guest said, "But you did not treat me that way."

"No, you are different. My other guests are much more trouble. When I offer them the best place in my house they say, 'Oh no, no thank you, you sit there.' When I offer them coffee they reply, 'Well, I don't know. I don't want to bother you.' I ask them to have dinner and they say, 'No, it will make too much fuss.' Those people I certainly beat in the morning."

* * *

Many years ago, a great Sufi sheikh went on the Pilgrimage to Mecca. At the end of his Pilgrimage he learned that all the pilgrims that year were found acceptable in God's eyes because of the perfect Pilgrimage of one man, a merchant from Baghdad named Abdullah ibn Ibrahim. This was a tremendous achievement. The rules governing the Pilgrimage are extremely numerous and complex. It is virtually impossible for most people to perform everything perfectly. So each pilgrim prays that God the Merciful and Compassionate will accept his or her imperfect Pilgrimage.

The sheikh decided to go to Baghdad and meet this Abdullah ibn Ibrahim whose Pilgrimage was so marvelous that all other Pilgrimages were made acceptable by it.

Earlier that year, in Baghdad, a son complained to his father that while he was at his best friend's house, they served dinner but did not give him anything to eat. The father was shocked. One of the main tenets of Islamic hospitality is never to eat and let a guest go hungry. That kind of inhospitality could even be considered a sin.

The father went to his neighbor the next day and asked him about what happened. He said, "Please excuse me for bringing

this up. I know that you are a devout man of good character. I'm sure you would not violate such an important moral obligation without good reason."

The father was exactly right. If we see someone committing a fault it is our duty to point it out to them, to try and stop them from continuing to err and to see if we can help them. If you see a blind man walking toward a pit, it is your duty as a human being to cry out "Stop!" and if that doesn't work, it is your duty to grab the man and pull him back from disaster.

The neighbor answered, "Since you have asked, I'll tell you. I have said nothing to anyone before this, but my business has gone very badly this past year. For weeks, my family has had little or nothing to eat.

"Yesterday I came across a dead camel on the road. I cut off part of one leg and brought it home. As you know, this kind of meat is forbidden to Muslims. The only exception is if there is a real danger of starvation or malnutrition. So, the meat was lawful to my family but not to your son, and I could not serve it to him."

The father replied, "I wish you had come to me earlier. I have plenty of money. Please let me help you."

"No," said the neighbor. "God knows my situation even if other people do not. I rely on God for our sustenance. I would never have told you or anyone else of this, but I had to explain about your son."

The father insisted. "Please, for God's sake, accept my help. God has guided me to ask you and guided you to tell me. How can you say that God does not want me to be an instrument of Divine Mercy? Besides, I have saved up a considerable amount of money to go on Pilgrimage this coming year. I have been on Pilgrimage once before and so I have already satisfied my religious requirement to go. I don't need to go again, and I insist you take my Pilgrimage money for yourself and your family!"

When the sheikh finally came to Baghdad and met Abdullah ibn Ibrahim, the merchant was amazed to hear of his dream. The merchant said, "You see, I did not go on Pilgrimage this year. I had intended to go, but I gave the money I had saved to help my neighbor."

* * *

The prophet Abraham (God's Peace upon him) is the symbol of generosity and hospitality. He never ate unless there was a guest at his table. At one time, a whole month went by and no one came to his house. Nobody shared his food, so he hardly ate for the whole month. Finally he prayed to God and he said, "Oh, God, You have given me this wonderful habit of not eating without sharing my food with someone else. I haven't eaten for a whole month. I wonder if there are other people like me."

God told him, "Go and travel in the world and see if there are others like you."

Travel is commanded of us by God. It is only through traveling that we, God's creatures, can meet each other. In these meetings of minds and hearts, misunderstandings dissolve and friendships are begun.

So Abraham began to travel. Finally he found someone who begged him to accept his hospitality, saying, "Look, three months I haven't eaten because I haven't had somebody at my table." Although Abraham had not eaten for one month, here was somebody who had not eaten for three months because nobody had come to his house as a guest.

Abraham happily accepted the invitation of this wonderful man. After dinner, it was Abraham's custom to pray. He said that he would include his host in his prayers and asked the man to pray for him. His host replied that he had given up making such prayers. He had prayed for something for many years, and since God did not choose to answer his prayer, he felt he was not worthy to make such prayers. Abraham asked, "What was your prayer?" His host replied, "I have heard that there is a great prophet here on earth, a special friend of God, by the name of Abraham. For years I prayed to meet him. But my wish was not granted. My mouth cannot be worthy to make such prayers to our Lord. You pray instead."

* * *

Some years later, after Abraham returned home, there came a knock at the door. He opened the door, to see an unkempt traveler, covered in dust and dirt. Abraham realized that this man could not be a believer so he asked him what his religion was. "I am a fire worshiper," said the man. When he heard this, Abraham thought of converting him from his false, idolatrous beliefs. So he sent the man away, saying "I cannot help nonbelievers and fire worshipers. Come to faith, to true religion and worship of God. Then I will be happy to have you as my guest."

That night, God spoke to Abraham.

"Abraham, I do not refuse this man his sustenance, although he denies Me and refuses to follow My commandments. So then how could you, My servant, refuse to feed him? Go to him at once and bring him to your table!"

The next morning, Abraham began searching for the stranger. He traveled for months until he finally caught up with the man in Medina. He told the fire worshiper what God had said to him and brought the man back to his home, and gave him a royal welcome. Touched by this evidence of Divine Mercy, the fire worshiper embraced the true religion of Abraham.

* * *

One day the venerable Abu Bakr (May God be pleased with him), intimate friend and father-in-law of the Prophet and first Caliph, saw some of the first fresh dates of the season in the market. He bought a bundle of them as a present for the Prophet. The Prophet Muhammed (God's Peace and Blessings upon him) loved fresh dates very much. Abu Bakr placed the dates in front of the Prophet. As he was reaching for them, a simple desert bedouin who was sitting in the back said "O Prophet, I like fresh dates very much. May I have them?" Muhammed gave all the dates to the bedouin. Umar (May God be pleased with him), the second Caliph, bought the dates from the bedouin and placed them once again in front of the Prophet. But the bedouin came up to Muhammed again and asked him a second time for the

dates. The Prophet again gave the man the whole bunch of dates, not taking a single date for himself. Ali (May God be pleased with him), the son-in-law and nephew of the Prophet, bought the dates from the bedouin and gave them to Muhammed. Once again the bedouin asked for the dates. The Prophet replied, "O bedouin, do you really like these dates, or are you in business?"

* * *

After Umar (may God be pleased with him) became Caliph, he was sitting with his companions when three young men came up to him. Two of them were holding the third. The Caliph asked what they wanted. The two men replied that the third man killed their father. They caught him and brought him to the Caliph for justice.

Umar asked the third man if this was true. He replied, "Yes, it is true. There are no witnesses to the fact but God. If you will permit me, I will tell you what happened, and I will accept your verdict, whatever it will be. I came to Medina this morning, to visit the tomb of the Prophet. I tethered my horse in a date orchard and washed off the dust of the road. Before I finished, my horse began eating dates. As I grabbed him, he broke off one of the date trees' branches. Just then I saw an old man running toward me. Enraged, the man grabbed a large stone and threw it at my horse. The stone smashed my horse's skull, and my beloved stallion fell to the ground, dead. I went out of my mind with rage. I picked up the stone that killed my beautiful stallion and threw it back at the old man. He also fell to the ground, dead.

"I could have easily escaped, and no one would have known I killed him. But I would rather take my punishment here than in the hereafter. I didn't intend to kill the old man. I was just overcome with anger when he killed my horse."

Umar replied, "You have confessed to a major crime. In accordance with the religious law of Islam the penalty is death." Although sentenced to death, the young man remained calm. "As a believer, I am bound by the law. However, I have in my charge the property of an orphan. I hid the money in my village,

in a place known only to myself. If you were to kill me now, that money would be lost. Please give me three days' grace, so that poor orphan will not be deprived. Let me go and deliver that money to its owner."

"I cannot," said Umar. "I can only let you go if someone guarantees your return." The young man said, "O Caliph, I did not run away when I killed the old man. I could not then and I cannot now, for the fear of God has filled my heart." Umar replied, "My son, I believe you would not escape, but the law forbids me to release you without bail." The young man looked at the Companions present. He pointed to Abu Dharr (May God be pleased with him) and said, "He will guarantee my return." Umar turned to Abu Dharr and asked him if he agreed. "Yes," said Abu Dharr, "I guarantee that this young man will return and give himself up in three days." No one could object to this, because Abu Dharr was one of the best loved and most respected of the Prophet's Companions.

The young man left for his home. Three days passed and the two sons came to the Caliph. The young man was not there. "Abu Dharr," they cried, "where is the person for whom you stood bail? You stood guarantee for someone you did not know, a man you had never met. If he does not come back, we shall still insist on avenging our father." But Abu Dharr told them, "The three days are not yet over. If the young man has not returned when the time expires, then I will stand in his stead" The Companions present were in tears as the Caliph said, "Abu Dharr, the young man may come late, but you stood guarantee for three days only; as God is my witness, I shall certainly have to impose the sentence upon you." The Companions wept, for Abu Dharr was one of the finest and most devout members of the Muslim Community. All present were affected by an indescribable emotion, a mixture of sadness and grief. They offered to pay blood-money for the father's death, but the sons insisted on receiving a life for their father's life.

Suddenly the young man appeared, dusty and tired, just before his three days were up. Exhausted, he panted, "I hope I

didn't worry you. I got back as quickly as I could. I left the orphan with a trustworthy friend and handled all my own affairs. I wrote my will, then hurried back. I barely made it on time because of the heat. Now, carry out your sentence!"

Everyone marveled at this young man, who was so honest and so faithful. Seeing how they marveled, the young man said, "A man keeps his word. A believer is faithful to his promise. He who is not true to his promise is nothing but a hypocrite. Could I let it be said 'There is no fidelity left in Islam'?"

When Abu Dharr was asked whether or not he had known this young man, he replied, "No, I do not know him. I had never met him before. But to reject such a proposal, made in the presence of Umar and so many Companions, would have been too small-minded. Could I let it be said, 'There is no virtue left in Islam'?"

At this, the hearts of the young plaintiffs were moved. They renounced their demands for the young man's life. They would not even accept any blood-money. "Let us not cause it to be said, 'There are no compassionate men left in Islam.' We have renounced our claim with no intention but to please God!"

Be as true to *your* word! Be as faithful to *your* promise! The believer is faithful to his promise. Abraham was a prophet faithful to his promise, and he had his reward.

* * *

Dhu-l Nun (May his soul be sanctified) was going on Pilgrimage when he caught sight of a dog so thirsty he was licking the rocks of the desert. Having no water with him, he called out to those traveling with him, "I have made seventy Pilgrimages. I shall give the reward for all seventy Pilgrimages to anyone who gives water to this poor dog." That saint was ready to give his seventy Pilgrimages to get water for a dog. Imagine what it must be worth to satisfy the thirst of a human being.

* * *

A miser was sitting at an outdoor cafe, drinking his morning coffee, when a madman came up to him and demanded money for some yogurt. The miser tried to ignore him but the man refused to leave and created a big scene. Others offered him money but the madman insisted he only wanted money from the miser. Finally the miser gave him a few coins for yogurt. Then the madman asked for some more money for some bread to go with the yogurt. This was too much for the miser, who absolutely refused.

That night the miser dreamed he had gone to Paradise. It was a beautiful place, filled with rivers, trees and lovely flowers. After a while the miser became very hungry, but amidst all the beauty there was no food.

Just then an extremely handsome, radiant man appeared. The miser asked him if this was really Paradise and the man said that it was. Then the miser wanted to know where were the wonderful foods and the ambrosia of Paradise he had heard so much about. The man excused himself and left. When he returned, he brought the miser some yogurt. The miser asked for some bread to go with the yogurt and the man replied, "All you have sent here is this yogurt. Had you sent bread, I could give it to you also. What you have sown in the world is what you harvest here."

The next morning the miser awakened, covered with sweat. From that day on he became one of the most generous of men and fed all the beggars and the poor in town.

* * *

One of the ancient prophets was at a wedding. After the ceremony he told his followers that the groom was fated to die on his wedding night. However, the young man came to greet the prophet the next morning, to the amazement of all the followers. The prophet then brought his companions to the groom's house. He asked to see the young man's bedroom. With his staff the prophet flipped over the groom's mattress. Underneath the mattress an extremely poisonous snake lay coiled up.

The prophet asked the snake what it was doing underneath the bedding. The snake replied, "I was sent to bite the owner of this house. But I couldn't. I don't know what happened. I just couldn't move. It was as if I was bound by iron chains."

The prophet then asked the groom if there was anything special he did on his wedding night. The man replied that just before he was about to retire with his bride, a beggar came to the door. He gave the beggar a cup of milk. The prophet turned to his followers and said, "You see the importance of charity. That one cup of milk saved this man's life."

* * *

One of the values of traveling is seeing and learning about other peoples. Before I left my country I had the impression that hospitality and generosity were the hallmark of the Muslims, especially the Turks. But when I came to Europe and to America I found that you surpass what I thought was ours alone.

The old Ottoman hospitality was famous. My grandfather was the Halveti sheikh of Yanbolu, which is now in Bulgaria. The sheikh's brother, my granduncle, one day found a stranger at his door and brought him inside, as God's guest. He ordered his servants to kill a lamb and roast the whole lamb for dinner. The guest sat down and my granduncle served him. That was an Ottoman custom, for the owner of the house himself to serve the guest, even if the guest is a penniless wanderer. My granduncle did not even know whether this man was a Muslim or a Jew or a Christian. It didn't matter.

With the beautiful roasted lamb placed in front of him, the guest said, "Ah, it is wonderful, but this lamb can't be eaten just like that." The host said, "What do you need?" "Ah, if one would have a nice bottle of wine."

Imagine, this was the house of the brother of a sheikh, and in Islam not only is drinking strictly against the law, but even to offer a drink is unlawful. But my uncle did not object. He went out of the house to get wine. It was night and he had to go to a

nearby Bulgarian village. His own town was Islamic and there was no wine there. He got on his horse to leave. Imagine now, here was a Turk, a Muslim and a sheikh's brother going to buy wine from the Bulgarians in the middle of the night. That is the value of a guest.

As my uncle was leaving, the guest came to the door and shouted out to him, "And let it be good, old wine!"

So he went, embarrassed, and brought some wine from the neighboring village. When he returned the guest was gone. But the roasted lamb had come alive and was walking on the table, and there were pots of vinegar which had turned into thick, boiling honey, bubbling to the top, but not spilling over. (This, by the way, is a symbol of prosperity. After dinner last night I prayed, "Let it be eaten but not become less, and let it boil and bubble but not spill.")

* * *

As another example of hospitality in the old Ottoman days, everyone, rich or poor, had a guest house outside. Guests could come and stay in that house as if it were their own. They would be fed and taken care of. Finally, when they were ready to go they would even be given some money to spend on their way.

Guests could live as they pleased, as if at home. In the main house they would have had to follow the customs of the host, and may have felt constrained. The guest house was like one's own home. Food was sent from the main house, and anything else that was needed.

* * *

In the late nineteenth century, the Sultan's wife was a French lady, who had accepted Islam. She was a very generous person. She built several mosques and also a very large hospital, which is still in use today. When she built that hospital she set up a permanent trust to cover in perpetuity all needed salaries and expenses.

In the 1920s, the early years of the Turkish Republic, the

hospital director decided to change things. There was a tradition that everyone discharged be given enough money for three days' sustenance. The director thought, "This is ridiculous. We are already treating people for free here, and this tradition of giving them money is absurd. After all, we are in the twentieth century" He abolished the custom. All the money from the trust kept coming in, including enough money to pay those discharged. That night he dreamt of the hospital's founder. She came with an umbrella in her hand and beat him on the head with the umbrella, and said, "How dare you! Who do you think you are, miserable man, to abolish my act of generosity like that? You had better reinstate it."

He got up the next morning with bumps on his head, and re-established the tradition of giving money to patients upon their release.

* * *

Sometimes God makes you do in your prayers that which you are unable to accomplish in real life. For instance, most of us cannot afford to build a hospital. God may have you build a hospital in your dreams, and will give you the same reward as if you had really built the hospital.

Also, if God loves you, something you are destined to suffer may come to you in your dreams, and then you don't have to experience it in real life.

Intention is as important as action. For instance, you might pass in front of a hospital and say, "Ah, I wish that I had the resources to build a hospital like this." Then God rewards you as if you had built that hospital. The Prophet said, "The intention of the believer is better than the action of the non-believer."

When I was young, some of the wealthy families who lived in large houses had servants stand outside to invite people in for dinner. This would happen every Monday and Friday night, and for fast-break during the month of Ramadan, every night. The servants would almost force strangers to come in and have dinner. These days, because of the economic situation, all this

has changed. But still, our faith considers service to a guest equal to service to God. This is the principle of hospitality in Islam.

The Prophet once said, "Those who believe in God and who believe in the Day of Last Judgment and the Hereafter—treat well your guests." So your hospitality to us in America is a sign of faith of the most wonderful sort. God is showing the mirror of your hearts. May God appear in the clear mirror in your hearts. May God reward your generous hearts.